DIOR
THE LEGENDARY IMAGES

GREAT PHOTOGRAPHERS AND DIOR

Dior, The Legendary Images
Great Photographers and Dior
© 2014 Rizzoli International Publications, Inc.
300 Park Avenue South, New York, NY 10010
www.rizzoliusa.com

© 2014 Christian Dior

Edited by Florence Müller
Preface: Jean-Paul Claverie
Texts: Florence Müller, Sylvie Lécallier, Barbara Jeauffroy-Mairet,
Brigitte Richart, Farid Chenoune

Editorial Direction: Catherine Bonifassi, Anthony Petrillose
Art Direction: Daniel Baer
Production: Maria Pia Gramaglia
Editor: Daniel Melamud
Design Assistant: Kayleigh Jankowski

Editorial Coordination:
CASSI EDITION, Vanessa Blondel

English Translation: Gail de Courcy-Ireland

ISBN : 978-0-8478-4308-4
Library of Congress Control Number: 2014934291
Printed in Italy

DIOR
THE LEGENDARY IMAGES

GREAT PHOTOGRAPHERS AND DIOR

Rizzoli
NEW YORK

New York · Paris · London · Milan

CONTENTS

I
IMAGES OF
A LEGEND

II
PORTRAITS OF
CHRISTIAN DIOR

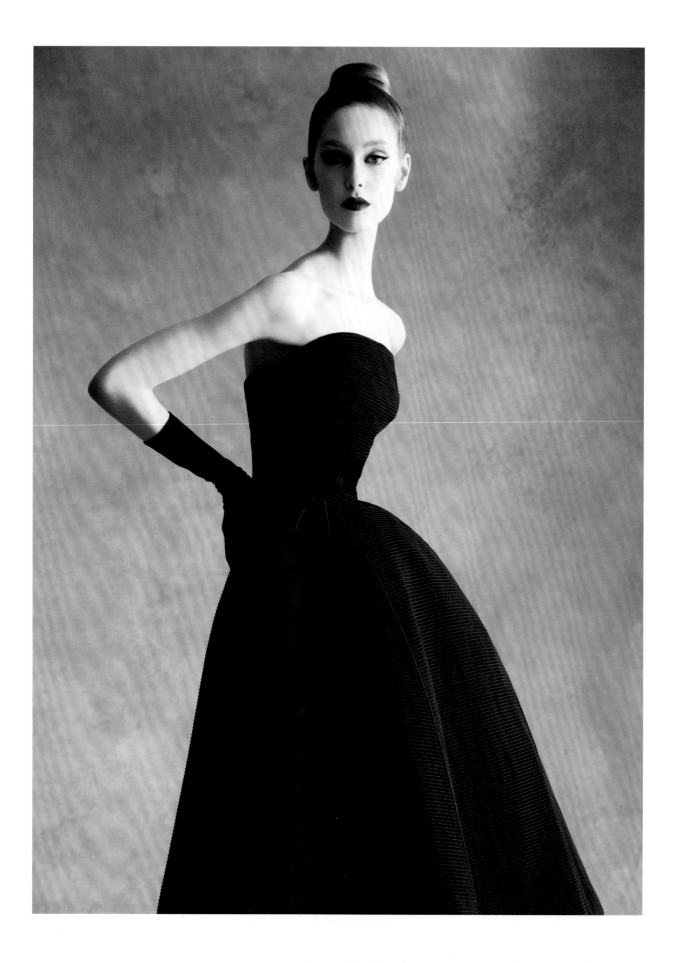

This catalogue is published to accompany the exhibition *Dior, The Legendary Images*, presented from May 3 to September 21, 2014 at the Musée Christian Dior in Granville, Normandy, and designed around the passionate dialogue between Dior and legendary photographers.

Photography contributed to Dior's worldwide success from the moment the House was founded. On February 12, 1947, American photographer Pat English documented Christian Dior's first collection, presented in the salons of 30 avenue Montaigne. Published in *Life* magazine, these pictures—believed to be the only existing photographs of this collection—showed the world that a "flower woman" had bloomed in Paris, born from the couturier's visionary genius: a cinched-in waist, rounded shoulders, an elegant silhouette with voluminous fabric. The press was in its golden age and the New Look was gaining momentum, inspiring the words of journalists everywhere.

The Dior style has continued to fascinate every generation of photographers since. In the postwar years, Richard Avedon, Horst P. Horst, and Clifford Coffin established the canon of Dior iconography: the framing, the lighting, the staging, and the refined poise of the model. Then, Irving Penn, Cecil Beaton, Erwin Blumenfeld, Henry Clarke, Peter Knapp, Guy Bourdin, and Helmut Newton shaped the Dior vision of women into an archetype of fashion photography. The genre has been celebrated in contemporary times by Patrick Demarchelier, Peter Lindbergh, Dominique Issermann, Nick Knight, Bruce Weber, and Willy Vanderperre.

Exhibition curator Florence Müller has brought nearly two hundred prints by fashion's greatest photographers to Granville. More than sixty haute couture dresses give life to the exchange of ideas between the fashion designer's dresses and outfits and the photographers' images, an exchange full of seduction and provocation.

The Musée Christian Dior, Christian Dior Couture, Christian Dior Parfums, and all those who have loaned works have made this project possible. Our association, Présence de Christian Dior, wanted it to be held in the heart of Les Rhumbs, Christian Dior's beautiful childhood home in which he found endless inspiration. The work of Dior and his successors, up to Raf Simons today, are brought together here in a manner that encompasses all the creative art forms and savoir faire on which fashion thrives. After illustrating the links that the House of Dior upholds with artists, the world of film, and the Impressionist movement, this year the Museum presents a photographic panorama that is a strong statement of the artistic dimension of Dior style.

Jean-Paul Claverie
President of the Présence de Christian Dior Association
Musée Christian Dior

Dior in Photos:
The Triumph of Style

Florence Müller
Curator of the exhibition *Dior, The Legendary Images*

The exhibition *Dior, The Legendary Images* is the newest stage in the Musée Christian Dior's exploration of the bonds between art and fashion. Since 1947, great photographers have enriched Dior creations with their vision, inspired by the unique style of the fashion house. Photographers construct their dialogue with the world at the juncture between the desire to embody the act of creation within reality and the aspiration for an aesthetic absolute. The Musée Christian Dior in Granville presents a history of Dior in images, a unique history in which dresses and fashion photography echo and complement one another, while the Musée d'art moderne Richard Anacréon in Granville simultaneously presents a retrospective dedicated to the photographer Marc Riboud.

The history of the House of Dior began just as photography was entering a golden age. Before the Second World War, the evolution of fashion photography mirrored the transformation in pictorial schools, from society portraits to pictorialism, modernism, and surrealism. With the exception of realism, photography did not adopt any unique expression until after the war, when Irving Penn, Richard Avedon, Henry Clarke, Louise Dahl-Wolfe, and Erwin Blumenfeld inaugurated a remarkable artistic language. In their wake, William Klein, Jeanloup Sieff, Peter Knapp, Guy Bourdin, and Helmut Newton infused their photographs with the spirit of the cultural and political revolutions of the 1960s and 1970s. From the 1980s, Peter Lindbergh and Paolo Roversi asserted the power of the image with their very special works. In the 1990s and 2000s, Patrick Demarchelier, Nick Knight, Jean-Baptiste Mondino, Tim Walker, Mario Testino, Willy Vanderperre, and Terry Richardson brought a new dimension to photography that was truly to scale with a globalized world.

The emblematic styles that have become part of the iconography of the House of Dior all feature in this panorama—a selection of nearly two hundred photographs, more than sixty dresses, and fifty documents—that spans over sixty years of fashion photography and illustrates the collaboration between image and fashion. Original prints are shown, on loan from the archives of *Vogue Paris*, Condé Nast New York,

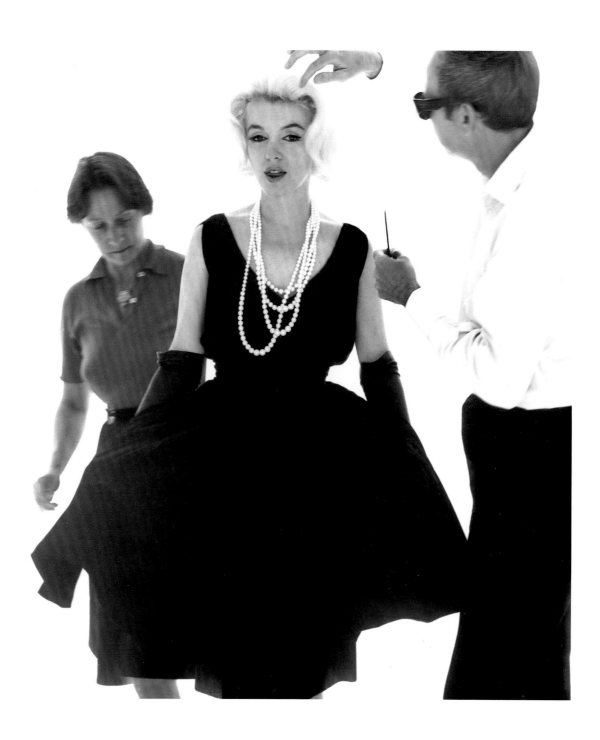

PREVIOUS PAGE
Patrick Demarchelier, 2013.
Sonnet dress, Autumn–Winter 1952
Haute Couture collection, *Profilée* line.

ABOVE
Bert Stern, 1962.
Marilyn Monroe dressed in Dior.

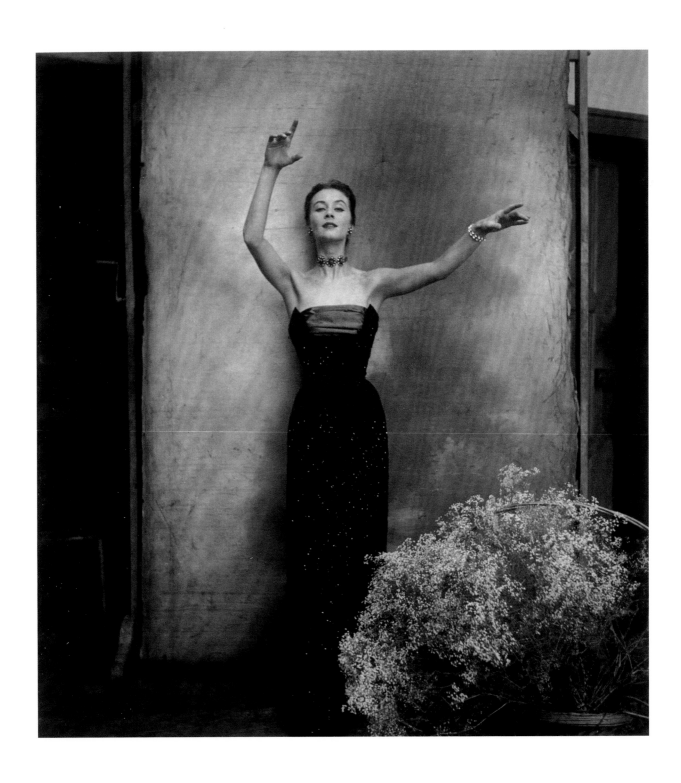

Cecil Beaton, 1951. *Turquie* dress,
Autumn–Winter 1951 Haute Couture
collection, *Longue* line.

French *Elle*, the photography departments of the Musée des Arts Décoratifs and the Palais Galliera in Paris, and the Museum at the Fashion Institute of Technology in New York. Contemporary prints from the photographers themselves complete the selection. The dresses on display come from the collections of the Musée Christian Dior, Dior Héritage, the Musée des Arts Décoratifs, the Palais Galliera, and private collectors. The exhibition showcases the complementary nature of two mutually beneficial facets of fashion while celebrating the words of Sir Cecil Beaton: "The fashion photographer's job is to stage an apotheosis."[1]

[1] Quoted in *Cecil Beaton*, edited by Dr. David Mellor (London: Barbican Art Gallery, 1986), 79.

I

IMAGES
OF A LEGEND

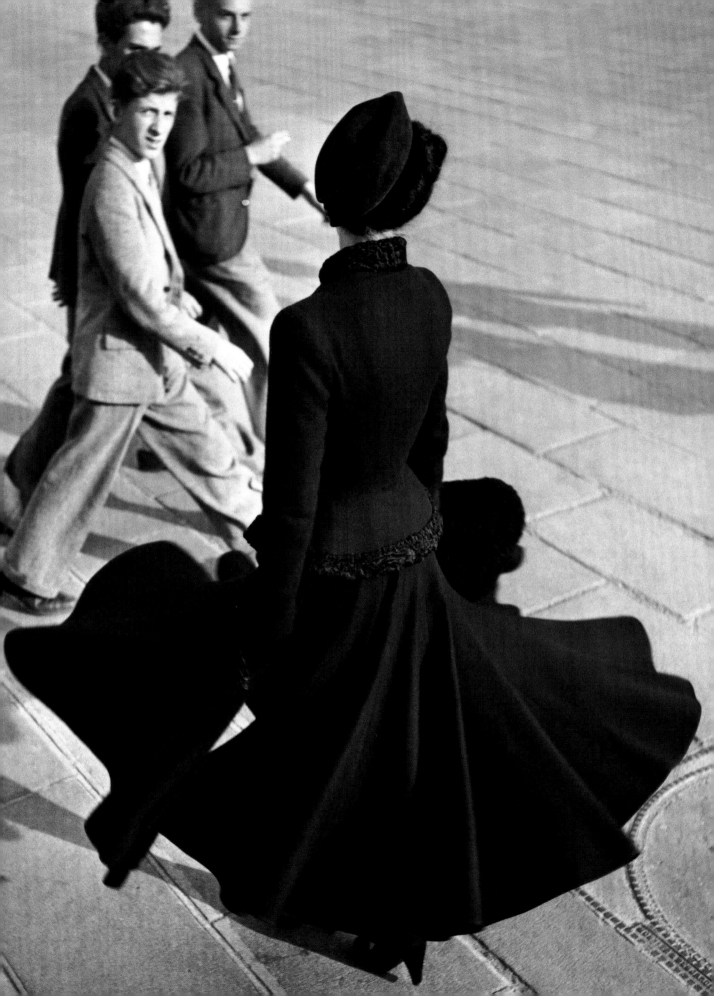

1947-1957:
The Legendary Pictures

Sylvie Lécallier
Head of the Photography Collection at the Palais Galliera

Few women, only a handful of privileged clients, models and fashion editors, have had the luxury of being able to actually see, touch, or wear the haute couture dresses that Christian Dior designed from 1947 to 1957. But many women have memories of the photographs of Dior outfits, captured by the likes of Richard Avedon, Irving Penn, Henry Clarke, and Erwin Blumenfeld. Published in *Vogue* or *Harper's Bazaar*, these photographs helped bring about the birth of a couturier and the creation of a legend. Today they belong to the House of Dior heritage, as much as a delicately embroidered Dior evening gown or the sophisticated cut of a Dior wool suit.

The 1950s heralded an era of rich collaboration between France and the United States that was particularly meaningful for Dior. Transatlantic clients had high purchasing power and American magazines played a key role in the revival of fashion photography in the postwar years by hiring young photographers, who brought a keen, lively eye to the renaissance of Parisian haute couture. Captured by their lenses, the models were so photogenically modern that they became the image of a self-sufficient Parisian woman at a time when a career as a cover girl was starting to be a gateway to stardom.

Irving Penn used daylight and the subtlety of the studio to portray the Autumn-Winter 1950 *Oblique* line: in his images, a broad sleeve or the huge *Illusionniste* coat collar made its mark, underscoring the slim waist of this sharp silhouette. The black-and-white photographs abstract the clothing to the essentials: structure and geometry rather than color and material. Lines were the architecture that Dior used to construct his dresses, suits, and coats, and he communicated extensively on their importance to his designs.

Other photographers captured the mood of the times with authentic settings in the City of Light, focusing on the couturier's intrinsically Parisian flair. In Clifford Coffin's shot, a backlit pose in profile highlights the bustle of the *Cocotte* dress while the vertical lines of the window and the slant of the broom accentuate the garment's geometry and place it naturally in the setting of place du Palais-Bourbon. In Henry

14

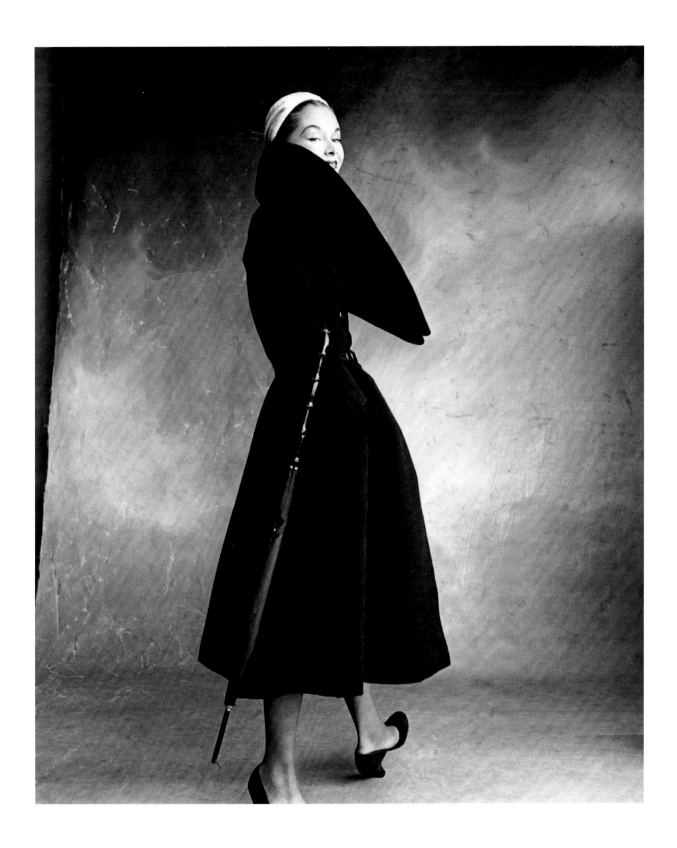

PREVIOUS PAGE
Richard Avedon, *Renée, The New Look of Dior*, place de la Concorde, Paris, August 1947. *Palais de Glace* ensemble, Autumn–Winter 1947 Haute Couture collection, *Corolle* line.

ABOVE
Irving Penn, 1950. *Illusionniste* coat, Autumn–Winter 1950 Haute Couture collection, *Oblique* line.

15

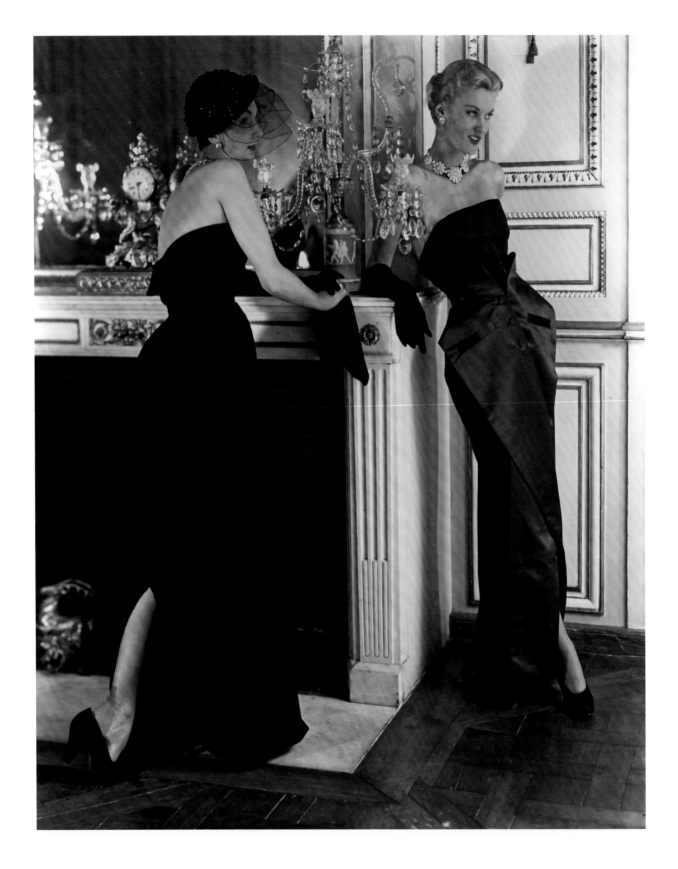

Horst P. Horst, 1949. *Ciseaux* and *Camaïeu* dresses, Autumn–Winter 1949 Haute Couture collection, *Milieu du Siècle* line.

Clarke's photograph, a hat, a glass of champagne, a mirror, and the model Dovima combine to epitomize chic at the restaurant Lapérouse.

Meanwhile, Willy Maywald, Louise Dahl-Wolfe, and Norman Parkinson staged Dior's romantic and theatrical vision of his magnificent evening and ball gowns. While the dozens of yards of fabric that went into these confections prompt comparisons to the extravagant crinoline dresses of the Second Empire, these gowns, featured in every collection, especially evoke the glamour of Dior; surrounded by columns, curtains, staircases and mirrors, they fill an image and spill out of the frame.

Starting as sketched-out lines that the couturier drew in private, Dior's dresses became photographic images inscribed in our collective memory. The couturier acknowledged the decisive impact this transformation had on his work: "These revelations are a proof of the independence of my creations from their creator: they also demonstrate their disconcerting precision."[1] The fragile balance between the style of an image and the rendering of a dress reaches perfection in the photographs presented here.

[1] Christian Dior, *Dior by Dior* (London: Weidenfeld & Nicolson, 1957), republished by V&A Publishing, 2012, 59.

Louise Dahl-Wolfe, 1950.
Schumann dress, Spring–Summer 1950
Haute Couture collection, *Verticale* line.

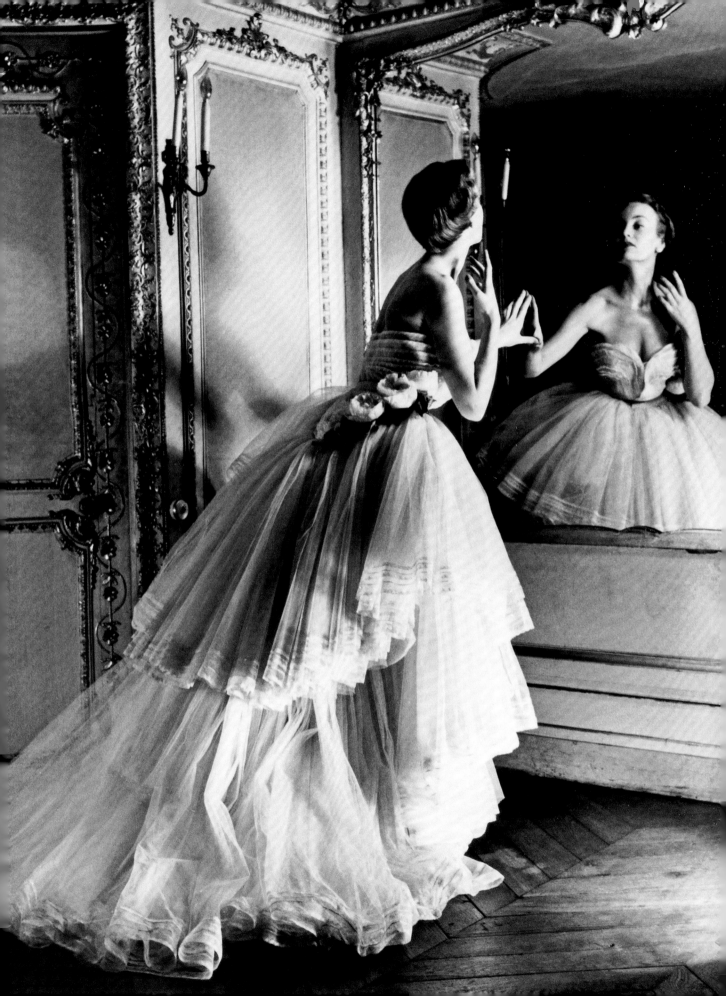

Horst P. Horst, 1947. Marlene Dietrich and
her daughter Maria Riva, both dressed in Dior.

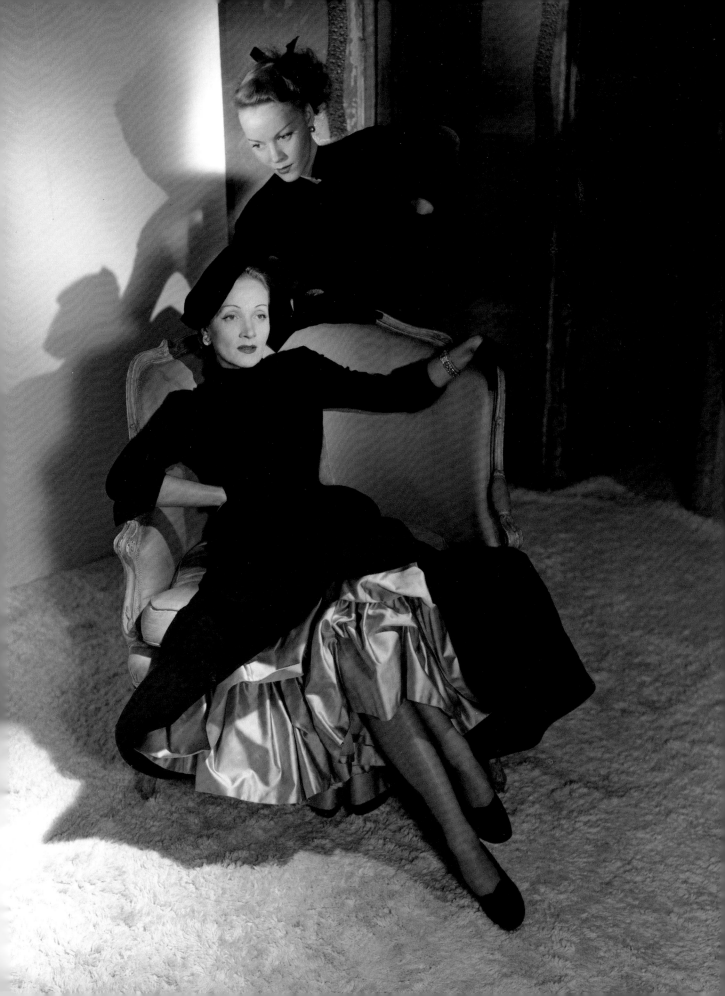

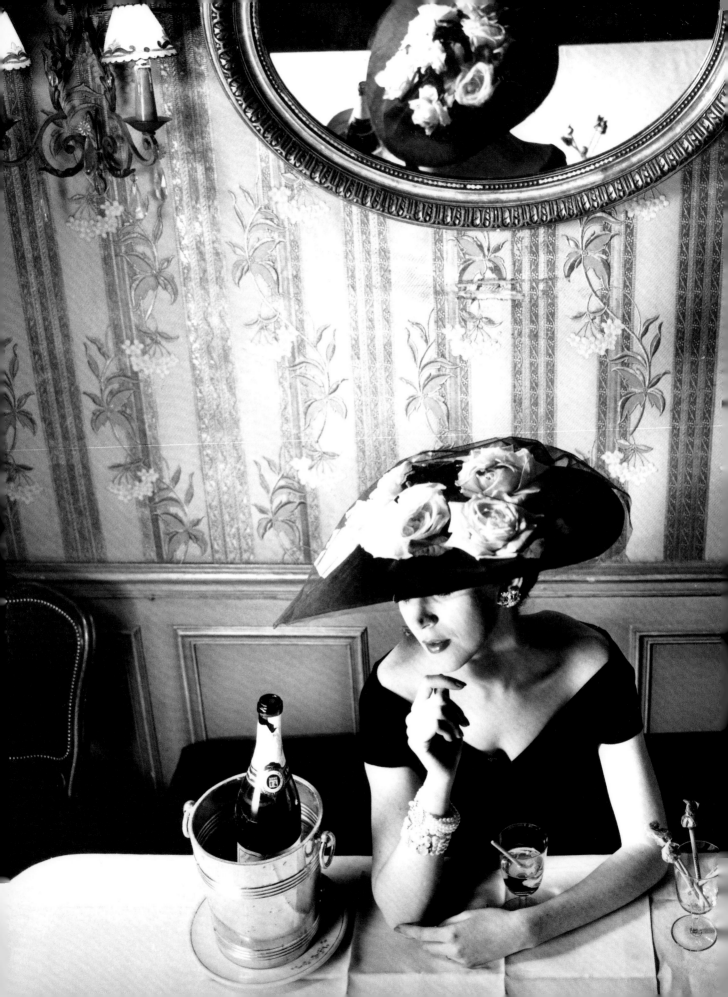

Henry Clarke, 1956. Hat from the
Raout silhouette, Spring–Summer 1956
Haute Couture collection, *Flèche* line.

23

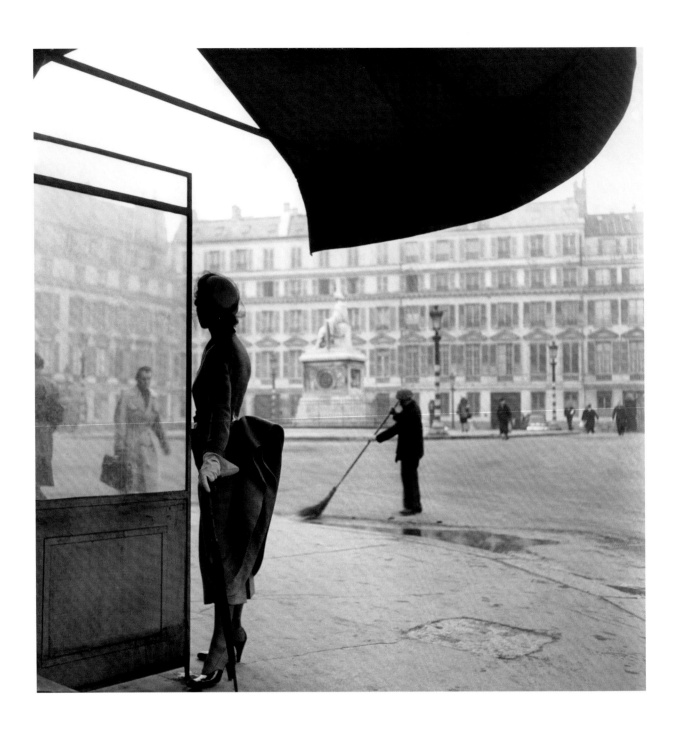

ABOVE
Clifford Coffin, 1948. *Cocotte* dress,
Spring–Summer 1948 Haute Couture
collection, *Zig-Zag* line.

OPPOSITE
Arik Nepo, 1948. Dress from the
Autumn–Winter 1948 Haute Couture
collection, *Ailée* line.

Irving Penn, 1950. *Barometer* dress, Christian Dior-New York Spring–Summer 1950 collection.

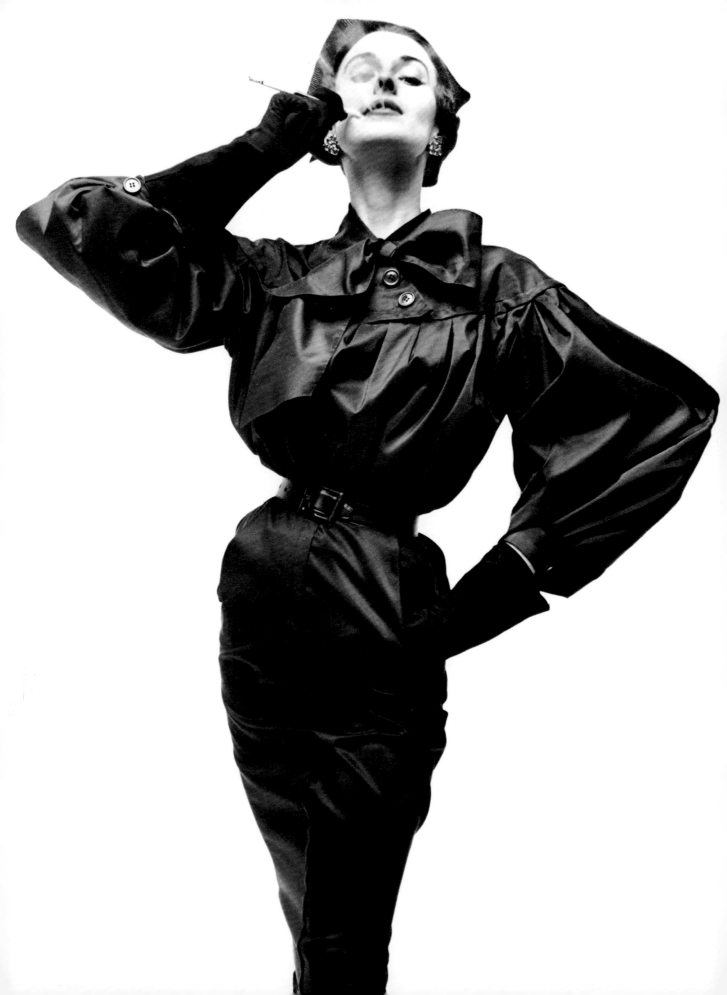

Henry Clarke, 1957. Ensemble from the
Spring–Summer 1957 Haute Couture
collection, *Libre* line.

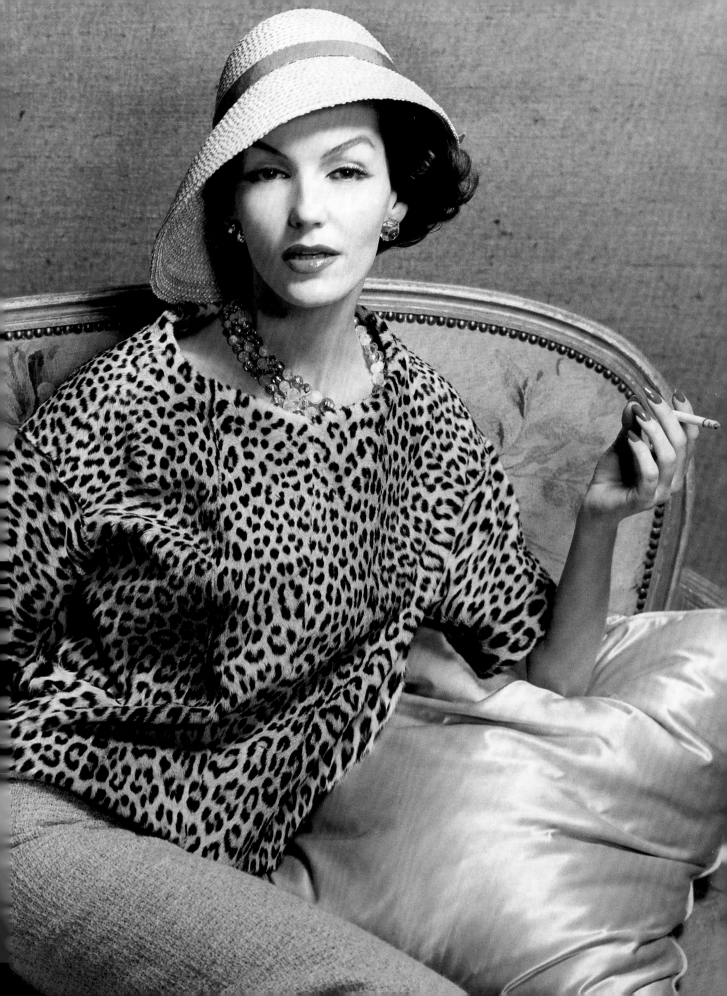

Erwin Blumenfeld, 1949. *Sargent* dress, Christian Dior-New York Autumn–Winter 1949 collection.

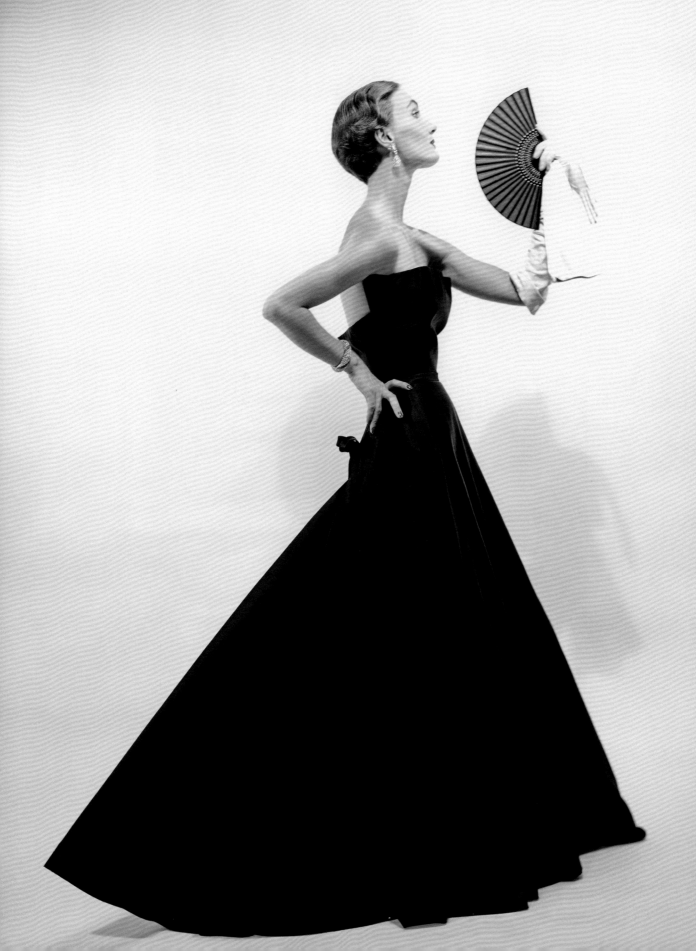

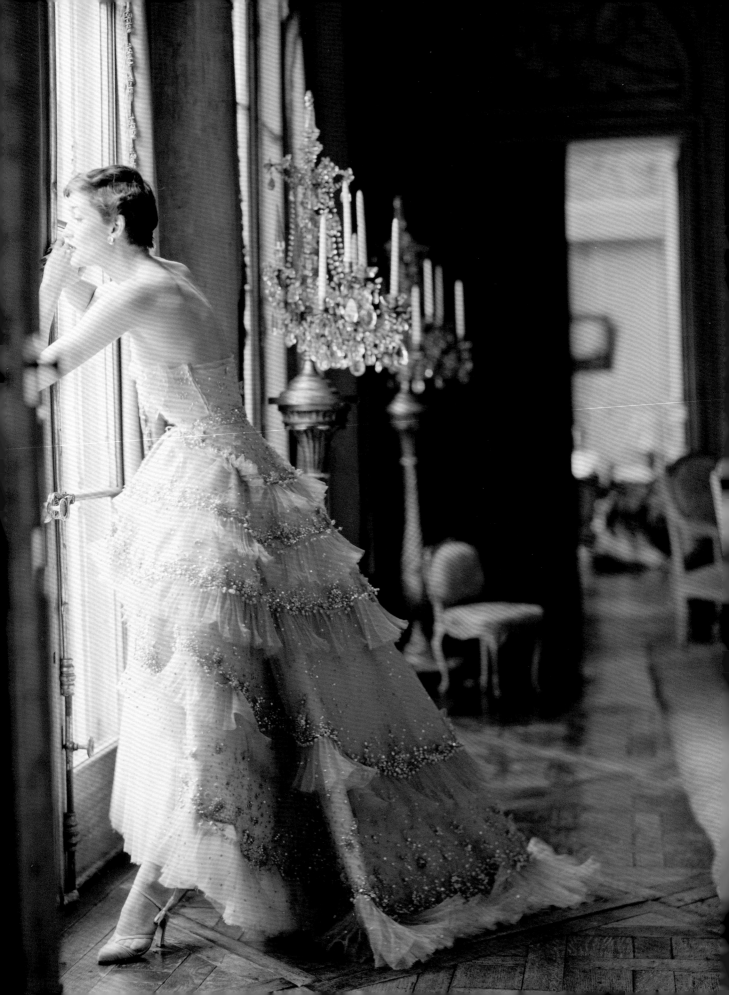

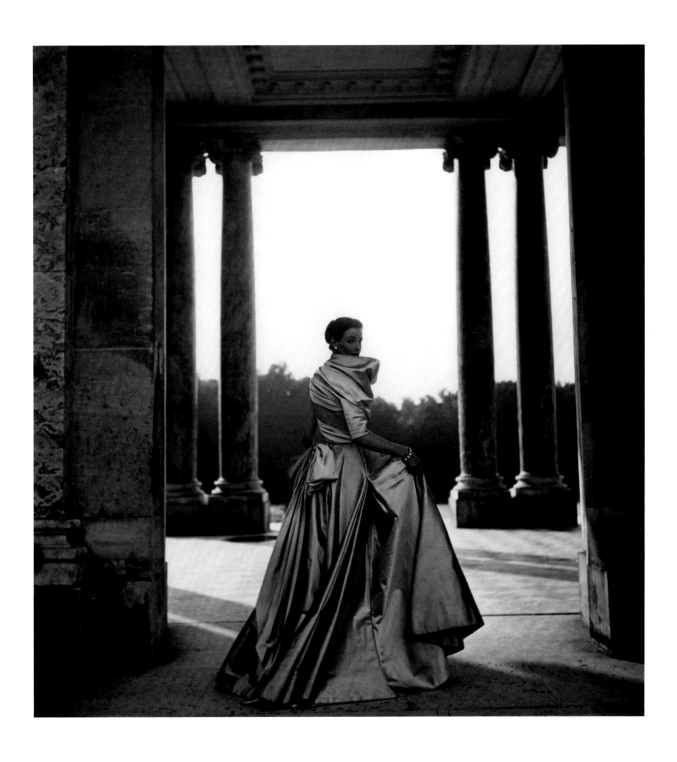

OPPOSITE
Norman Parkinson, 1950. *Mozart* dress,
Spring–Summer 1950 Haute Couture
collection, *Verticale* line.

ABOVE
Clifford Coffin, 1948. *Coquette* dress,
Autumn–Winter 1948 Haute Couture
collection, *Ailée* line.

33

Dovima with Elephants by Richard Avedon

Barbara Jeauffroy-Mairet
Associate Curator of the Exhibition

The most famous fashion photograph went down in history for being so unexpected: never had an haute couture model been photographed in a circus! Depicting the model Dovima posing with elephants and dressed in a Dior sheath dress, it is one of Richard Avedon's most iconic images. Published in *Harper's Bazaar* in September 1955, it illustrated "Carmel Snow's Paris Report," which used Paris as a setting.

After shooting on place de la Concorde, in the Marais, and at the Palais-Royal gardens, Avedon decided to set up his studio in the menagerie at the Cirque d'hiver, where a glass roof let in diffuse yet ample daylight. The circus had been in the Bouglione family since 1934 and one of Bouglione's sons, Emilien, still remembers the day the photographer arrived: "Dovima's dressing room was made of screens that had been set up in the stables, where large trunks filled with dresses were delivered." [1] The idea for the shot came to Richard Avedon while he was scouting the location: "I saw the elephants under a huge skylight and I knew in a flash." Dovima was one of his favorite models and she rose to the challenge. "She was never afraid of the elephants," Emilien recalls. "She struck a pose as soon as Jumbo, Mery, Tarzan, and Sabu raised their trunks whenever my brother Sampion called out, *"Tromba!"* Emilien remembers that Richard Avedon moved quickly: "He worked with several cameras to ensure one was always loaded." Two of the shots taken appeared in a spread in *Harper's Bazaar,* but the one of Dovima wearing the *Soirée de Paris* evening gown, designed by Christian Dior's young assistant, Yves Saint Laurent, is the picture that Richard Avedon deemed integral to his oeuvre. In 1978 he had a giant print of it made for his exhibition at the Metropolitan Museum of Art in New York, *Richard Avedon: Photographs 1947–1977,* a print that he then displayed in the entryway of his Manhattan studio for twenty-five years.

[1] All quotes from Emilien Bouglione are taken from an interview with the author.

34

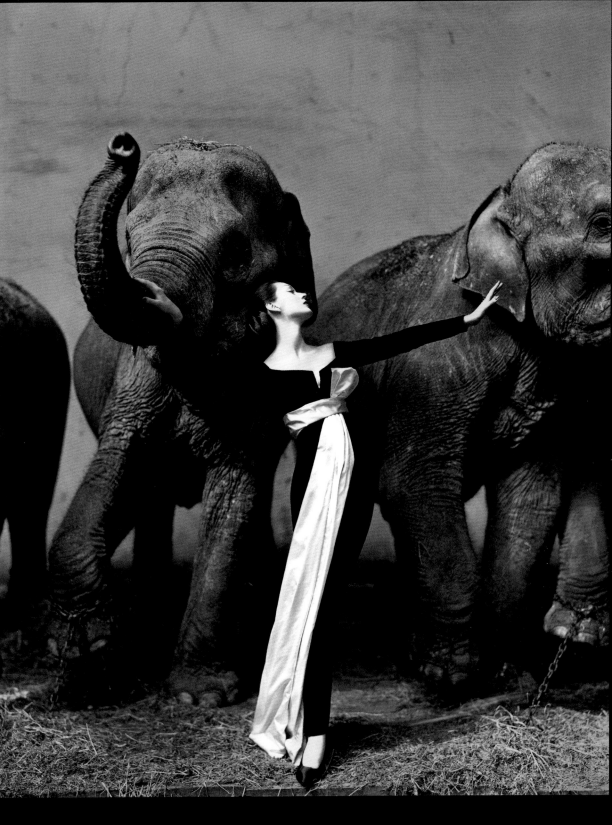

Richard Avedon, *Dovima with Elephants,*
Cirque d'Hiver, Paris, August 1955. *Soirée
de Paris* dress, Autumn–Winter 1955
Haute Couture collection, *Y* line.

II

PORTRAITS OF CHRISTIAN DIOR

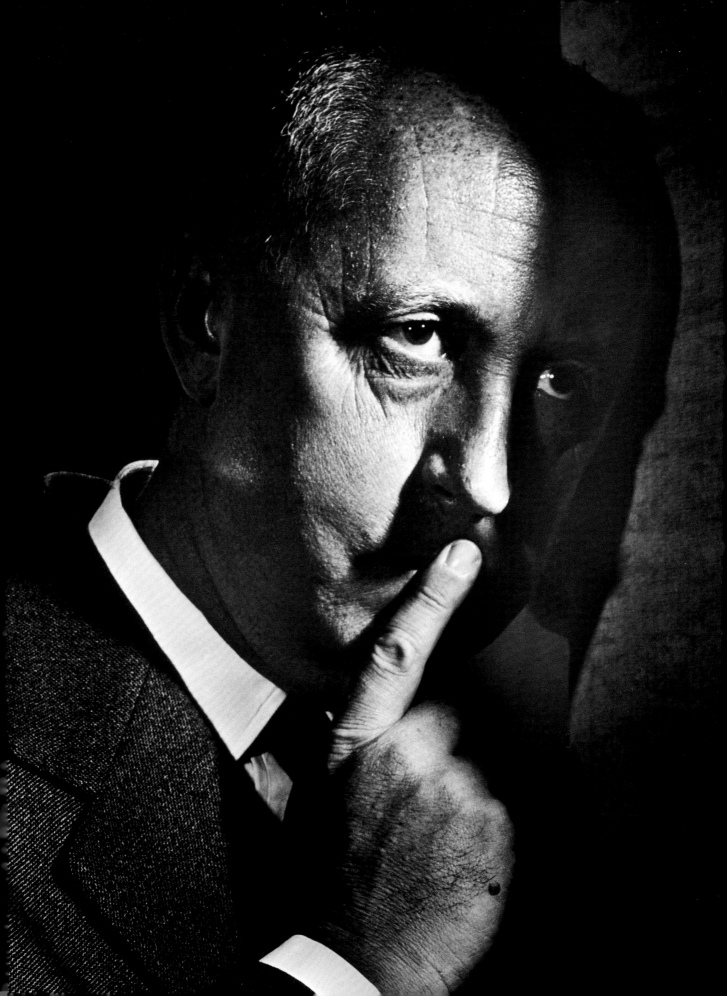

Christian Dior Through the Lens
of the Great Photographers

Brigitte Richart
Curator of the Musée Christian Dior in Granville

When comparing the anonymous photographs of Christian Dior as a youth in Granville with shots of the couturier at the height of his fame, taken by the greatest photographers, it is striking to see the similarity in attitude: the later images are portraits of a man who, beyond his physical maturity, had not fundamentally changed. He was still a shy and retiring man who did not like to reveal his feelings. He rarely smiled and sometimes displayed the sorrowful expression of shy loners, to whom he related. He made a veiled confession to harboring this temperament in his memoirs in 1956, recalling his youth in Granville: "This isolation suited my tastes."[1]

As if to make up for his natural shyness, Christian Dior was always portrayed within the artifice of a particular setting or pose. The context of his portraits was astutely chosen by the couturier, as he wanted images of himself to demonstrate his success and convey his values. The success is seen in the grand properties of a man who had lost his childhood home in the 1930s. Ruined by the Wall Street crash in 1929, the Dior family were forced to get rid of their Parisian apartment and their house in Granville. At the time, Christian Dior "sought refuge in other people's houses." This difficult period heightened his awareness of the thing that mattered most to him: "I was doing well enough to realize the chief ambition of my life—and have a home of my own." In his Parisian homes, which were used as the setting for his portraits by Brassaï (the apartment on rue Royale) and by Cecil Beaton (the town house on boulevard Jules-Sandeau), the decor reveals key aspects about the man and his tastes, for "living in a house which does not suit you is like wearing someone else's clothes." The interior is bourgeois Parisian but also reveals the art lover—a chance to recall his past as a gallery owner in the 1930s, when he rubbed shoulders with the most up-and-coming artists of his day.

His other homes were at Milly-la-Forêt near Fontainebleau and Montauroux in the Var region. Christian Dior wanted to portray an image of a simple man: "Simplicity is indispensable, the simple good taste of France of old." Lord Snowdon and Louise Dahl-Wolfe both shot the couturier in an intentionally casual pose,

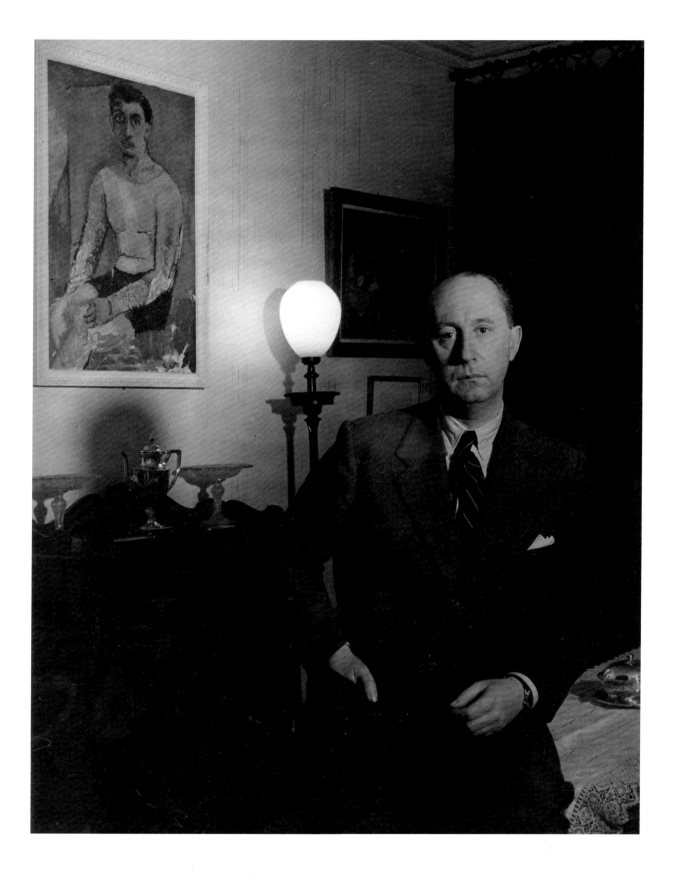

PREVIOUS PAGE
Yousuf Karsh, 1954. Portrait of Christian Dior.

ABOVE
Brassaï, circa 1947. Christian Dior in
his apartment on rue Royale, Paris.

39

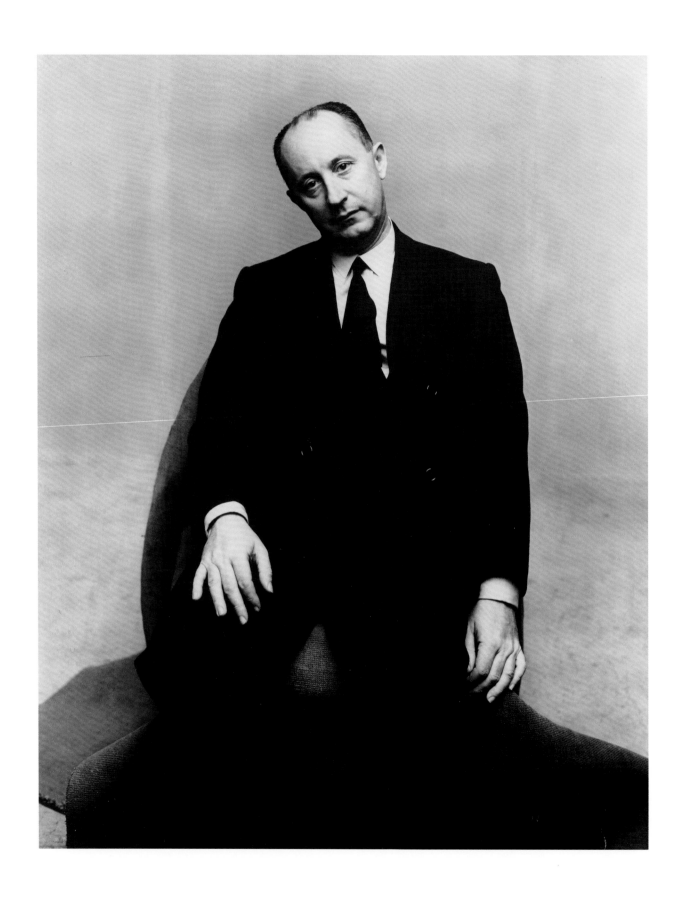

smoking a cigar and sporting a blazer, sitting on a low wall or playing cards—"one of my favorite distractions"—in his garden at cocktail time.

The portrait by Yousuf Karsh is no doubt the most emblematic picture of Christian Dior, for it reveals his dual personality. Or, more specifically, the "other himself" (a term used as the title of an exhibition organized in 1987 at the Musée d'art moderne Richard Anacréon in Granville) whom the couturier invented. Playing on his signature use of contrasting shadow and light, the photographer presents two men: the couturier playing a role in the limelight, a finger raised enigmatically to his lips, "this Siamese twin to whom I owe my success, who appeared ever since I became Christian Dior . . . who lives entirely in the century to which he owes his birth," and the man hiding in the shadows who does not like to be exposed, "incapable of playing that role."

[1] All quotes from Christian Dior are taken from the book *Dior by Dior*
(London: Weidenfeld & Nicolson, 1957), republished by V&A Publishing, 2012.

Cecil Beaton, 1953.
Christian Dior in his town house
on boulevard Jules-Sandeau, Paris.

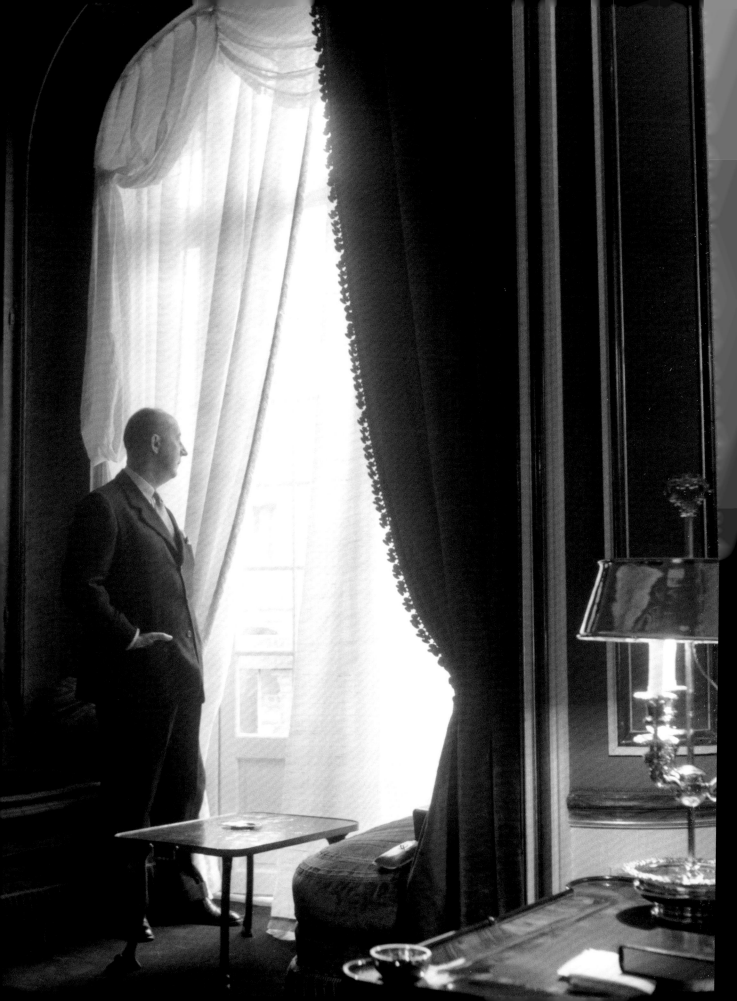

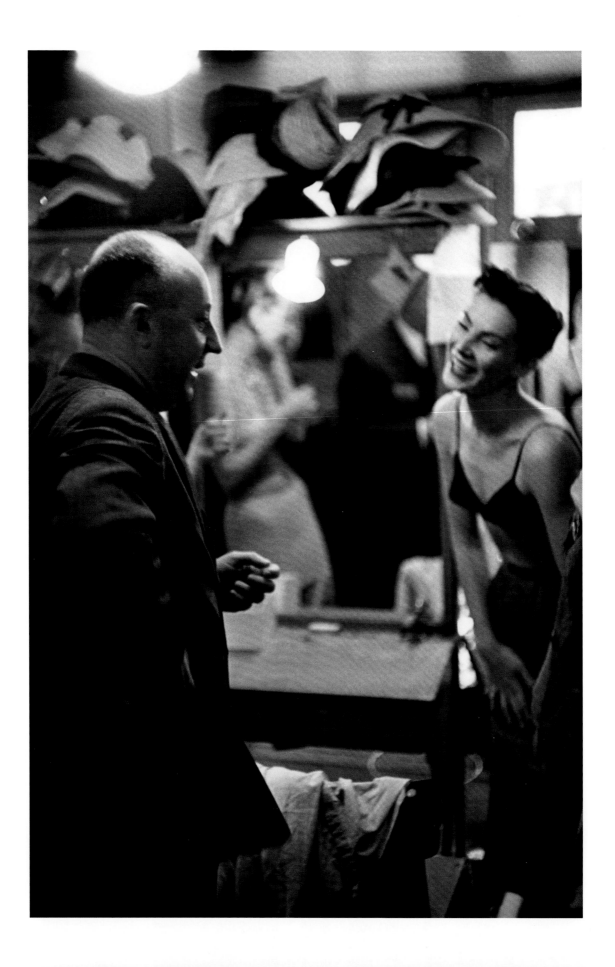

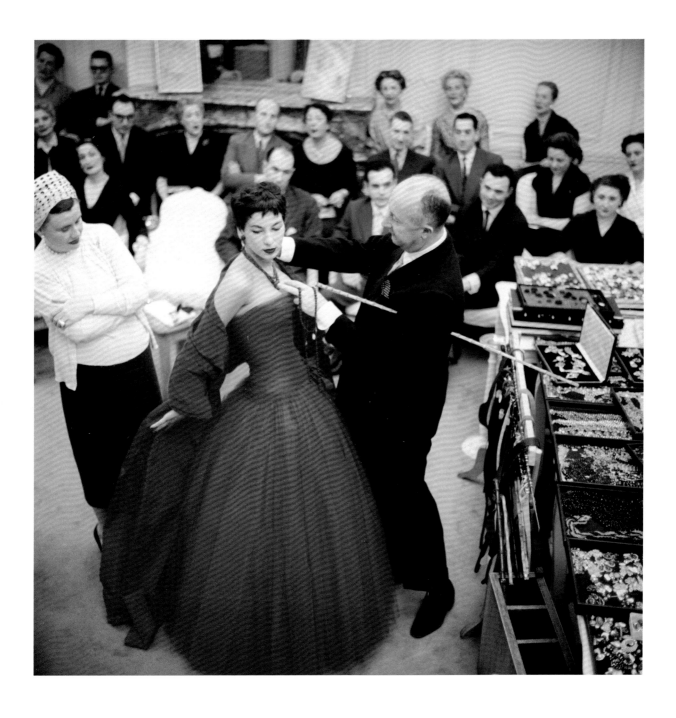

OPPOSITE
Henri Cartier-Bresson, 1951. Christian Dior and the model Lucky in the *cabine*, the models' dressing room.

ABOVE
Mark Shaw, 1954. Christian Dior adjusts the accessories to the *Zaïre* dress on his star model Victoire during rehearsal for the Autumn–Winter 1954 Haute Couture show.

Jean Chevalier, 1949. Christian Dior with the model Simone on the staircase of his couture house. Simone wears the *Miss Dior* dress from the Spring–Summer 1949 Haute Couture collection, *Trompe-l'œil* line.

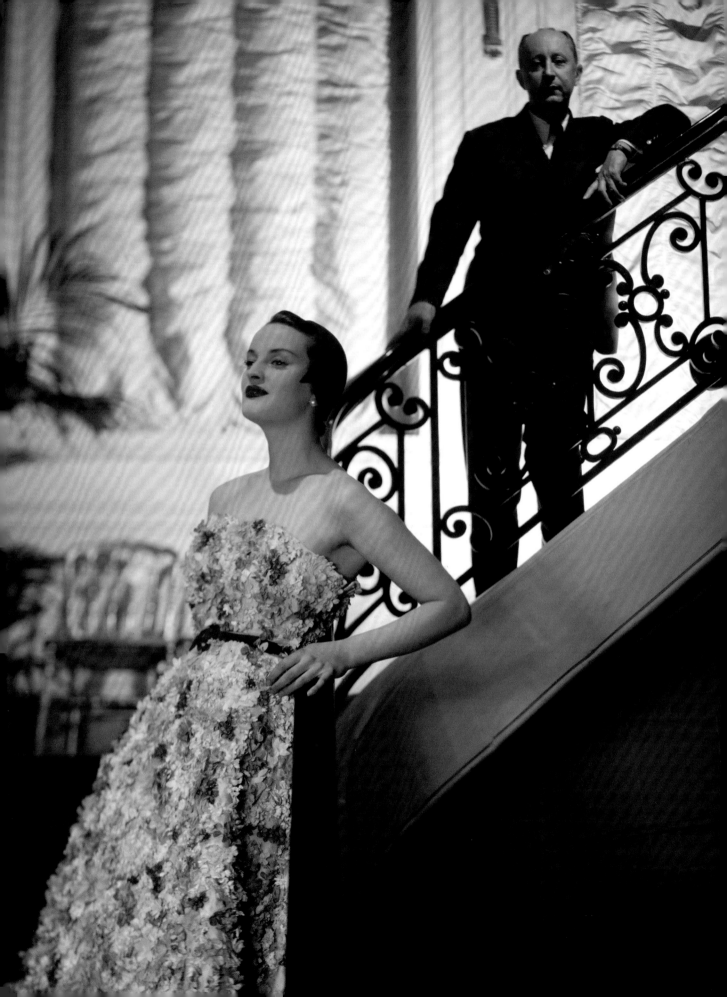

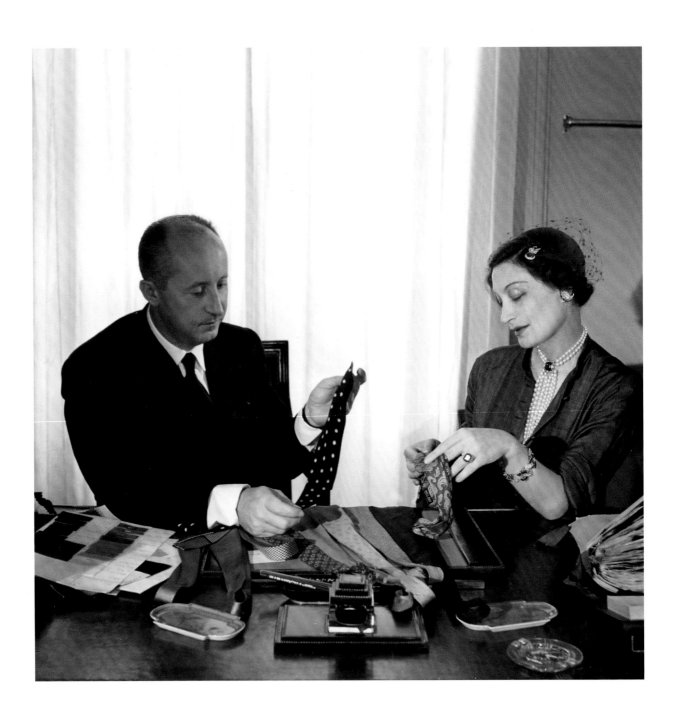

ABOVE
Willy Maywald, circa 1950. Dior and Mitzah Bricard, his muse and close colleague.

OPPOSITE
Henry Clarke, 1957. Christian Dior and the model Renée in the House of Dior couture salons.

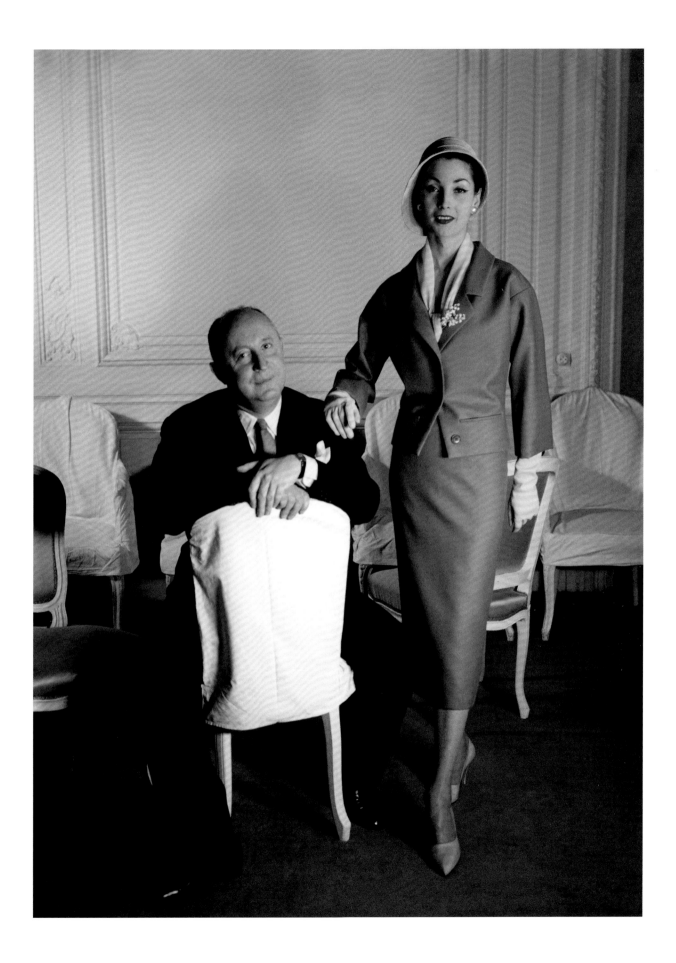

Christian Dior and Christian Bérard photographed by Louise Dahl-Wolfe

Barbara Jeauffroy-Mairet

After the euphoria of his couture shows, Christian Dior liked to withdraw to the country to replenish his energy. In the summer of 1947 he stayed at Fleury-en-Bière, near the forest of Fontainebleau. He rented a country house there opposite "Le Potager," which belonged to his friends Pierre and Carmen Colle; then, a year later, he bought the Moulin du Coudret at Milly-la-Forêt. Dior liked to invite his friends there for relaxed country weekends. Louise Dahl-Wolfe, Christian Bérard, and Boris Kochno were frequent visitors. Christian Bérard and Louise Dahl-Wolfe knew each other well: both worked for the prestigious *Harper's Bazaar*, Bérard as an illustrator and Dahl-Wolfe as a fashion photographer for the publication since 1935. At the time this picture was taken, she had just photographed some of the models from Dior's second collection. Louise Dahl-Wolfe was well known for her snapshot portraits, often taken outside.

Christian Bérard, nicknamed "Bébé," was an illustrator, painter, and a designer of both interiors and costumes, and had been a figure of Parisian society since the 1920s, when he spent time with Jean Cocteau, Max Jacob, Jean Hugo, and Henri Sauguet and first met Christian Dior. Dior showed Bérard's work in both of the art galleries that he ran from 1928 to 1934. Later, Christian Bérard was the inspiration behind the interior design for his couturier friend's Colifichets boutique, inaugurated on February 12, 1947. Both men enjoyed playing the game of patience (also called solitaire): Christian Dior loved card games and even named some of his outfits *Bridge, Canasta, Crapette,* or *Réussite.* Here Louise Dahl-Wolfe captures Christian Dior in a relaxed moment, playing patience in front of Christian Bérard. It is an intimate portrait of two friends.

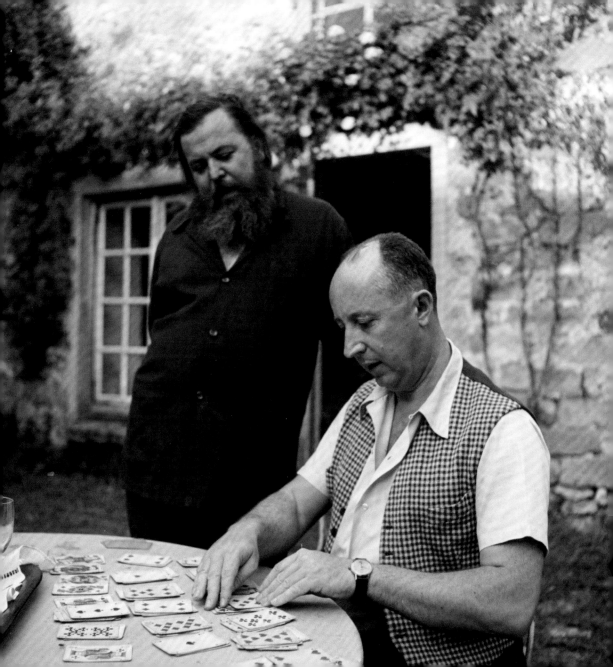

III

IMAGES BEYOND BOUNDARIES

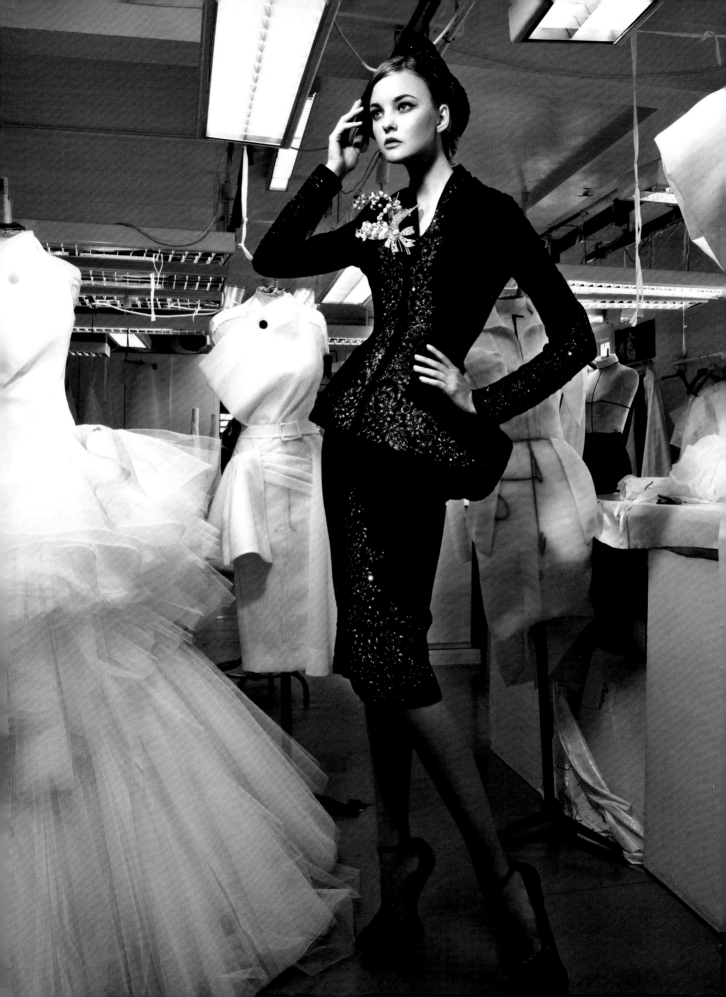

Dior as seen by the
Great Photographers

Florence Müller

Built on a strong aesthetic and cultural foundation, the Dior collections naturally give rise to a body of photographic work that is in harmony with the distinguishing characteristics of the House itself. In the best of such photographs, the photographer not only interprets the work by placing the model in a scene and a role that fit the dress she wears, he also communicates and amplifies the couturier's vision.

In 1946, Christian Dior took great care in choosing the setting for his future couture house. He imagined a nostalgic eighteenth-century atmosphere as the perfect backdrop of subtle elegance for his dresses. Serge Balkin chose this stage to photograph the famous New Look collection for the first story that *Vogue* devoted to the new couturier. From then on, photographers from Louise Dahl-Wolfe to Patrick Demarchelier have used this couture house "photo studio" to compose images with dual messages, superimposing day-to-day couture life over the presentation of new fashion. Louise Dahl-Wolfe offsets the slender silhouette of a Dior model against the stalwart line of saleswomen waiting for buyers. Willy Maywald and Patrick Demarchelier go deep into the ateliers to show that what happens behind the scenes is as important as what occurs at the front of the House. By placing the models around a ladder, Loomis Dean illustrates the never-ending work of fashion in tirelessly launching new designs.

Celebrated in pictures from 1947, 30 avenue Montaigne became *the* place to be in Paris for fashion photography. It is both a tourist attraction and a symbol of the naturally photogenic capital of elegance; as Helmut Newton described, "Every little particle of Paris life was a joy. I learned about fashion from the French—how they are born with it, the way they dress."[1] The perspectives and typical Parisian avenues go well with the constructive spirit of the Dior lines. The majesty of the Garnier Opera House staircase highlights an evening crinoline framed by Clifford Coffin, while its foyer is the stage where Willy Vanderperre casts a chiaroscuro illumination on his models. Bridges on the Seine, the verticality of the Vendôme column, and the rhythm of the columns in the Palais-Royal courtyard all structure the images, carving out perspectives and creating vanishing points. The photographs invite us on an elegant

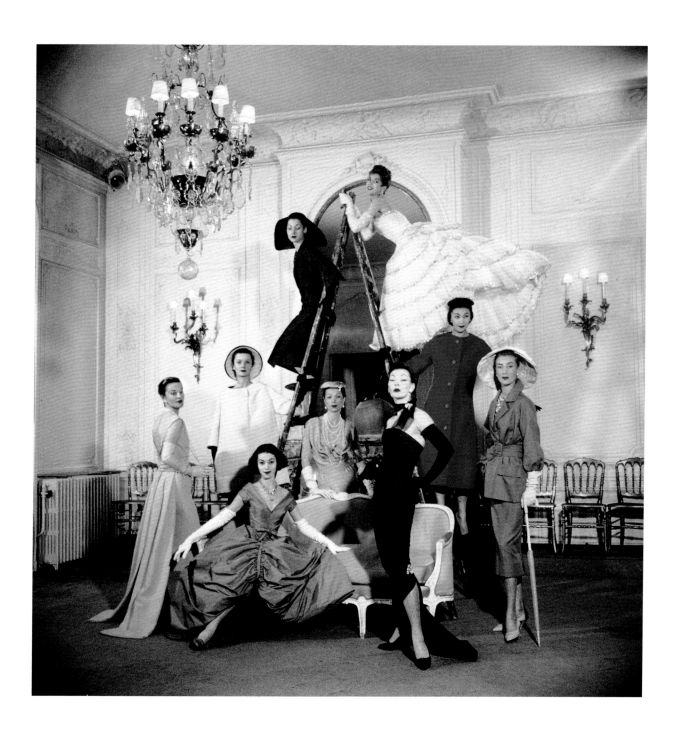

ABOVE
Loomis Dean, 1957. In the salons of the couture house on avenue Montaigne, the Dior models wear the silhouettes from the Spring–Summer 1957 Haute Couture collection, *Libre* line.

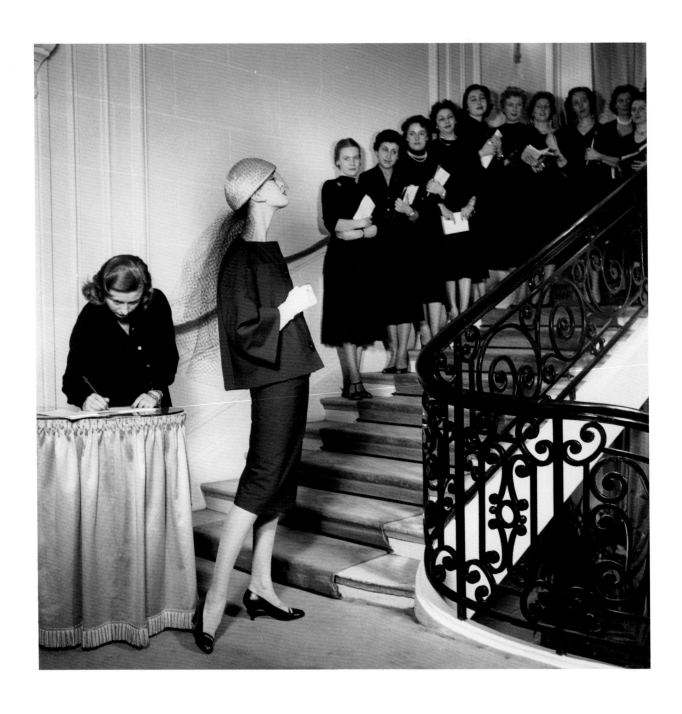

ABOVE
Louise Dahl-Wolfe, 1956. Saleswomen
line the stairs of the House of Dior before
a silhouette from the Spring-Summer 1956
collection, *Flèche* line.

FOLLOWING PAGES
Dominique Issermann, 1985.

picture-postcard journey: a Métro entrance for Mark Shaw, the place Vendôme for Robert Capa, and the banks of the Seine for Henry Clarke, all conjure up archetypes of a Paris enjoyed in carefree pleasure. Like a statue that is infinitely elaborate yet marvelously simple, the Parisian woman has posed for the lens over the decades with stature and confidence.

Beyond the borders of Paris and its perfect fusion with Dior style, the dresses find the spirit of 30 avenue Montaigne amid the gilt moldings and historic gardens of Versailles. In the 1950s, Clifford Coffin, Norman Parkinson, and Willy Maywald grasped the significance of this setting that matches the magnificent sumptuousness of Dior evening gowns. In the 1990s–2000s, Annie Leibovitz, Peter Lindbergh, and Patrick Demarchelier transposed Dior creations into an eighteenth century ringing with contemporary echoes. Inez van Lamsweerde and Vinoodh Matadin lit up the Hall of Mirrors and the Grand Trianon with fleeting appearances of bright, buoyant, fairy-tale beauty.

By straying from the heart of the House of Dior, the photographers ventured into images with unforeseen contexts, full of surprises and the excitement of the unfamiliar. Borne by its international success, the House of Dior set out from Paris to conquer the world, tracing the contours of its empire and drawing inspiration from the countries it won over. Fashion photography set off into this world with no frontiers, finding endless sources of inspiration from the Middle East to Japan, China, Africa, and Russia. Photographers are both great explorers and studio magicians, bringing wonder to those immersed in dreams of faraway lands. The iconography of the House of Dior is enriched by these scenes that tell the fictional story of each dress. The outfits acquire an imagined, rich dimension that transcends fashion and the present. "All these images of women accumulated over the years since the first days of photography have left an indelible mark on the collective subconscious."[2] They have become timeless and legendary—much like the House of Dior.

[1] *Helmut Newton: Autobiography* (New York: Nan A. Talese/Doubleday, 2003), 158.
[2] Polly Devlin, *Vogue Photographies de mode 1920–1980*, introduction by Alexander Liberman (Paris: Éditions du Fanal, 1980), 18.

Patrick Demarchelier, 2008. Natalia Vodianova
with dressmakers from the *Tailleur* (tailoring)
and *Flou* (dressmaking) ateliers. She wears a
coat from the Autumn–Winter 2008 Haute
Couture collection.

OPPOSITE
Willy Vanderperre, 2013.
Ensemble from the Spring–Summer
2013 Prêt-à-Porter collection.

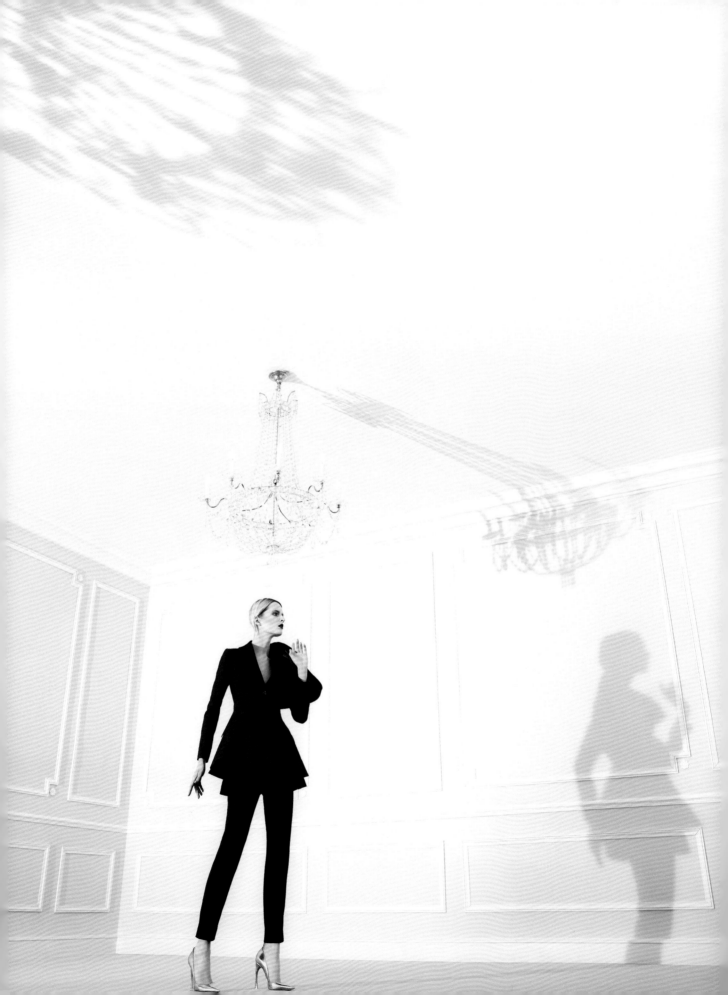

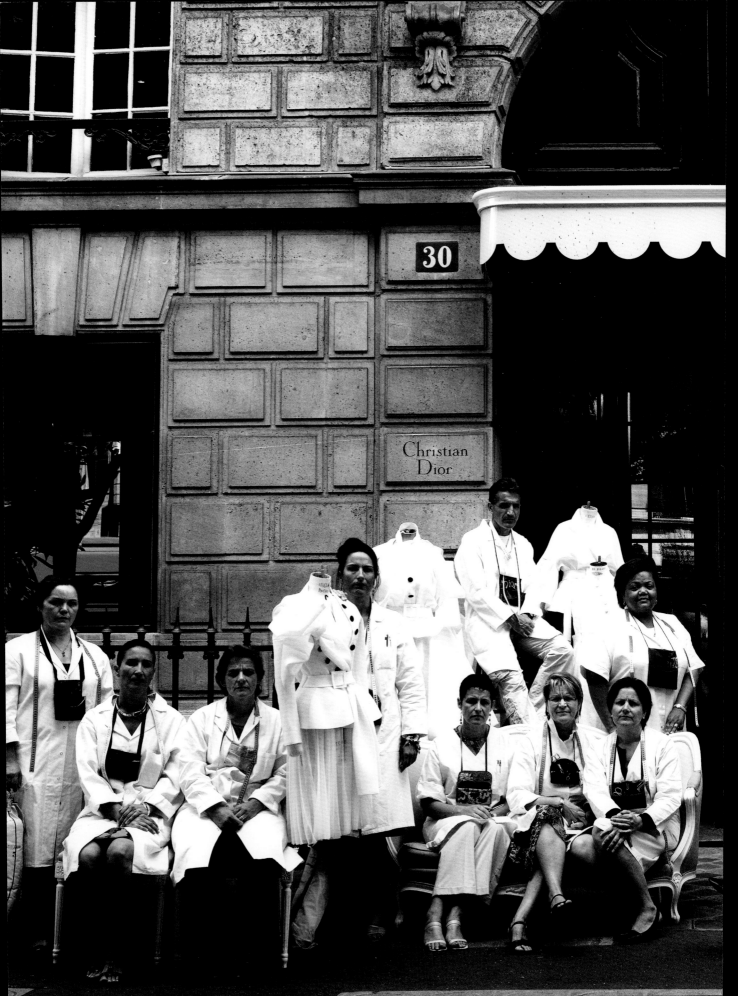

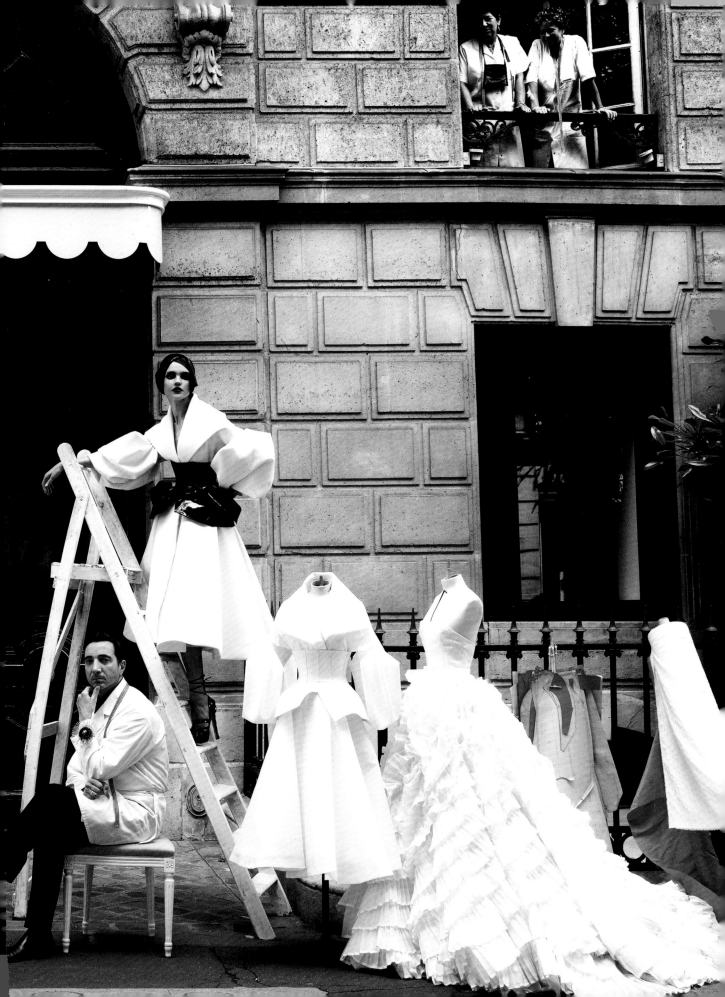

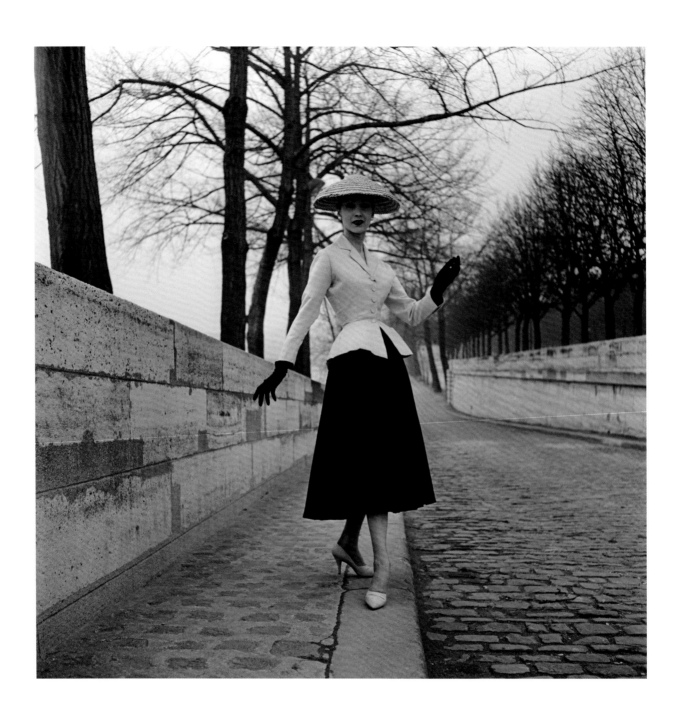

ABOVE
Willy Maywald, 1957. *Bar* ensemble,
Spring–Summer 1947 Haute Couture
collection, *Corolle* line.

OPPOSITE
Henry Clarke, 1955. On the Paris quayside,
ensemble from the Spring–Summer 1955
Haute Couture collection, *A* line.

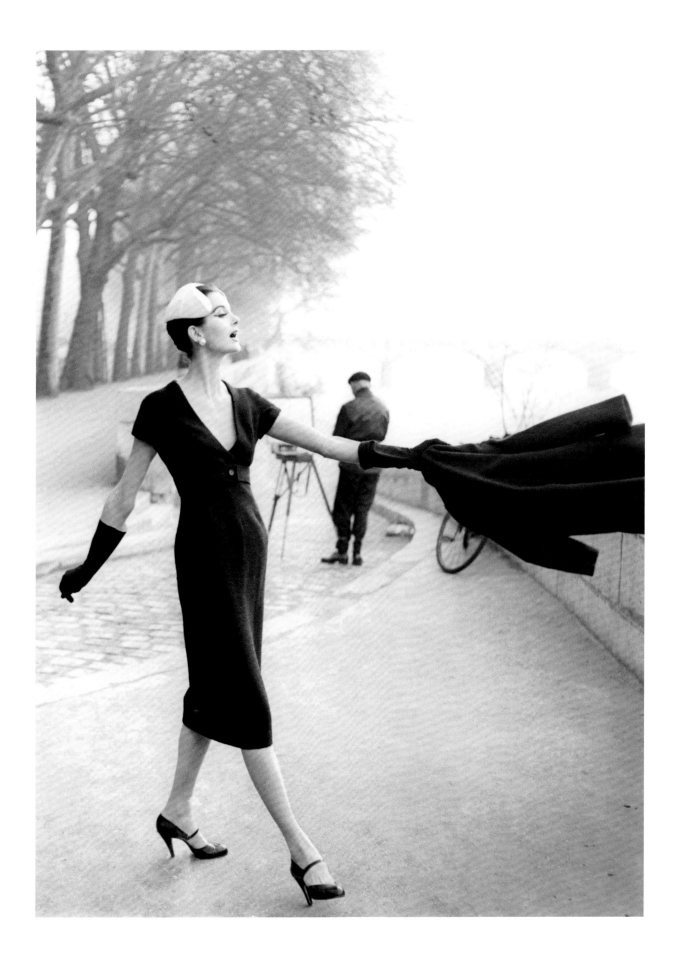

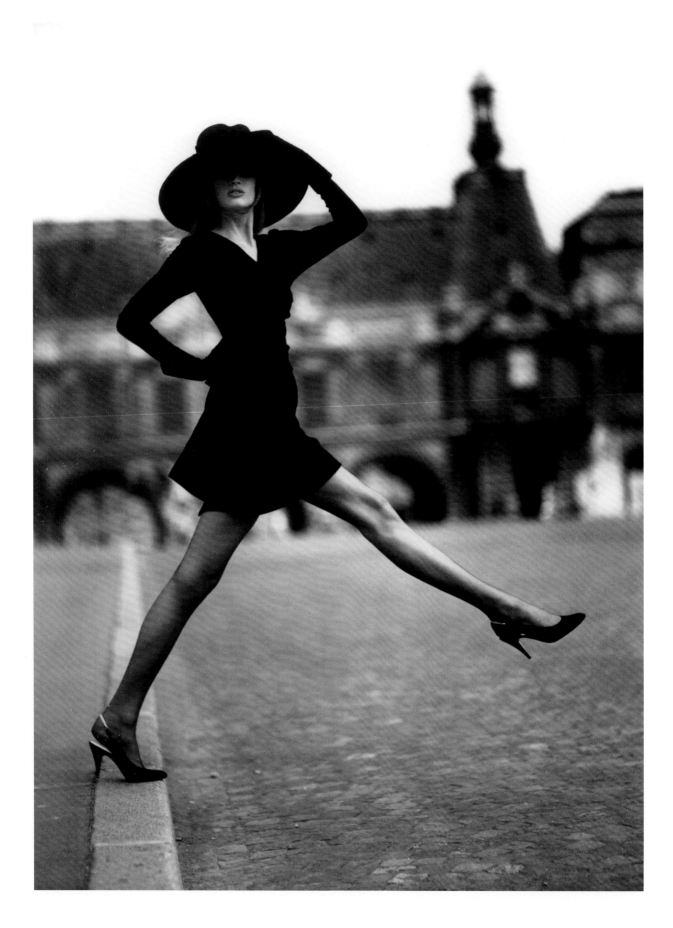

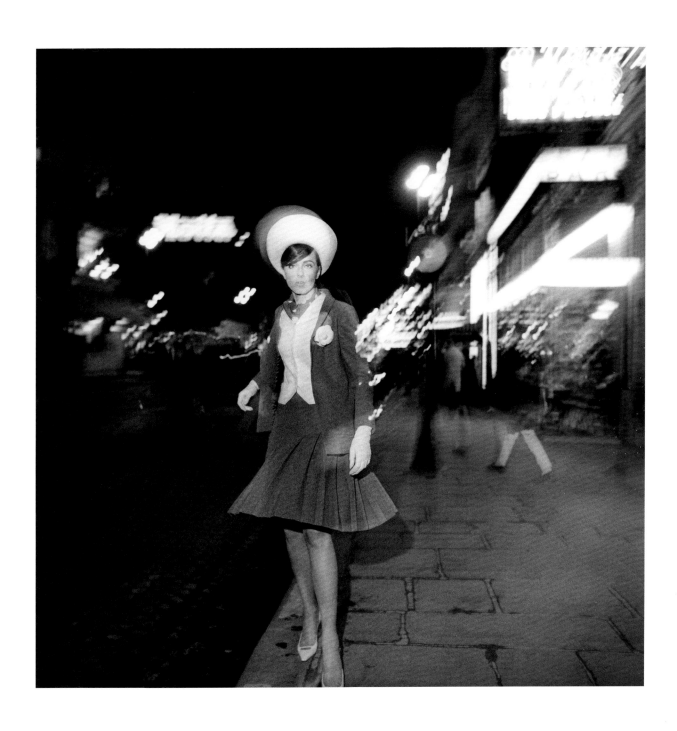

OPPOSITE
Arthur Elgort, 1988. Dress
from the Autumn–Winter 1988
Haute Couture collection.

ABOVE
Peter Knapp, *Rita Scherrer at the
Moulin Rouge*, Paris, 1963. *Park Lane*
ensemble, Spring–Summer 1963
Haute Couture collection.

67

Helmut Newton, 1978. Suit from the Spring–
Summer 1978 Haute Couture collection.
Copyright The Helmut Newton Estate.

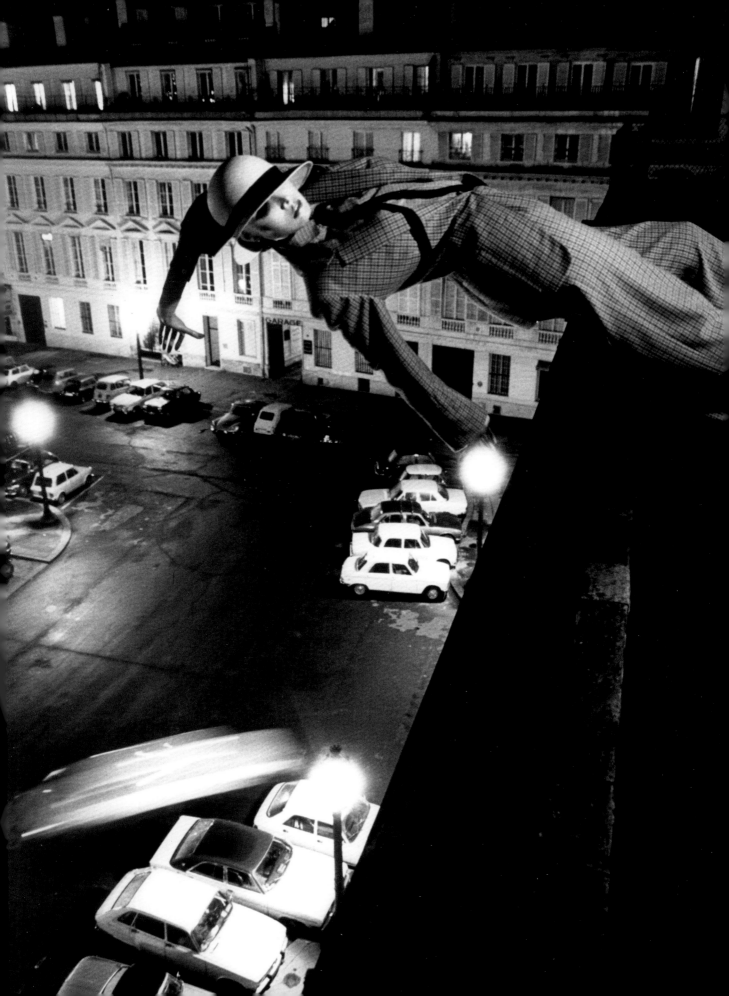

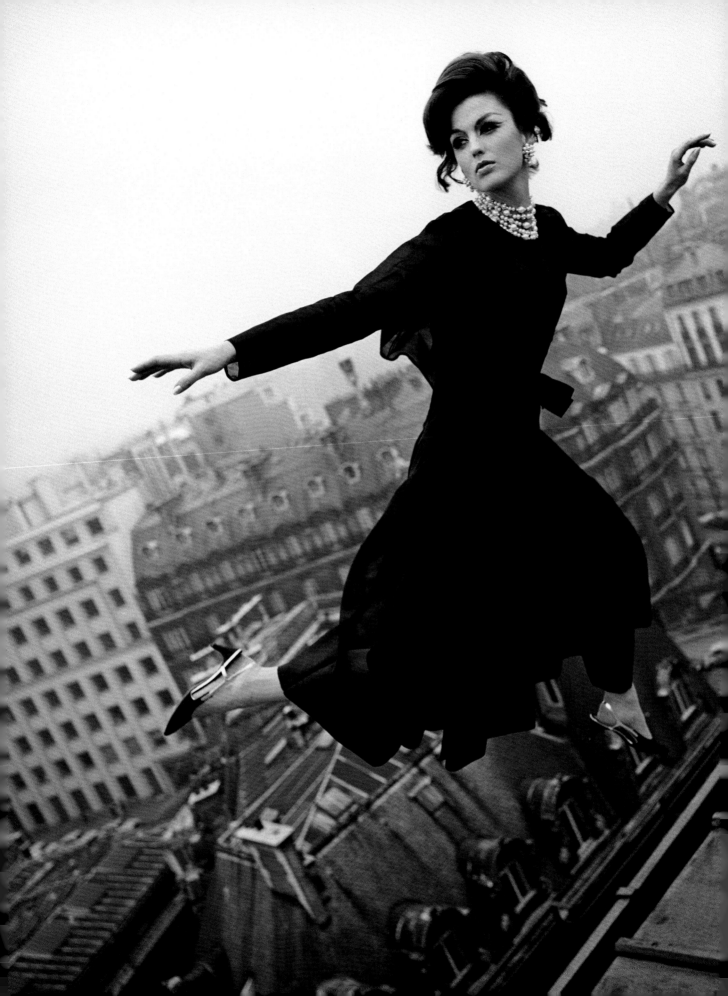

Melvin Sokolsky, 1965. Dress from the Spring–Summer 1965 Haute Couture collection.

Peter Lindbergh, 2008. Marion Cotillard,
the heroine in *The Lady Noire Affair*.

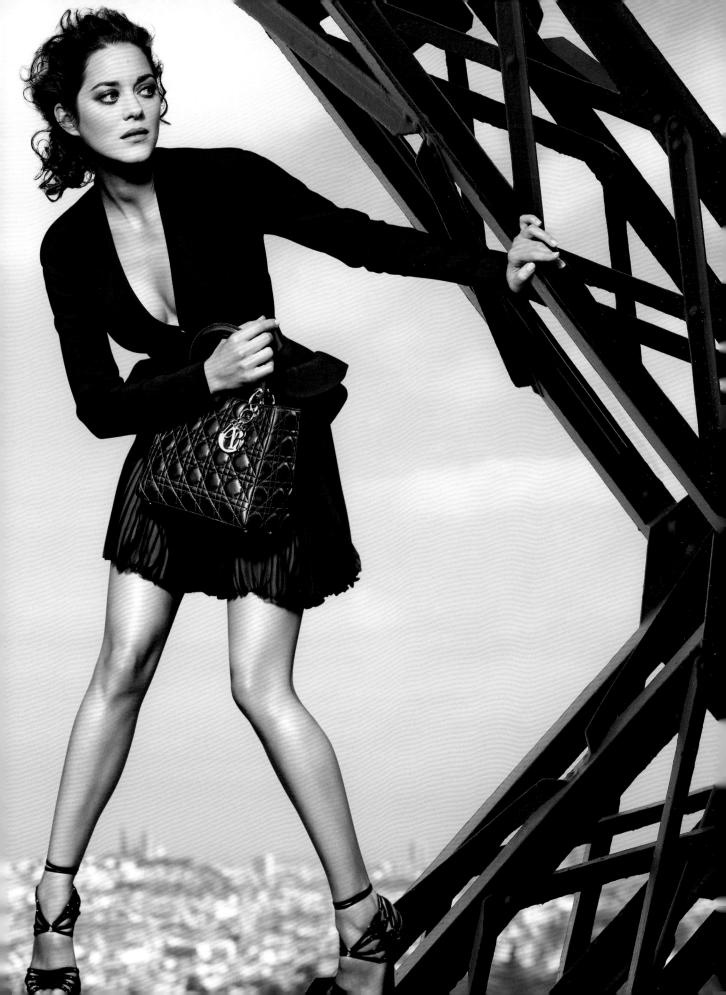

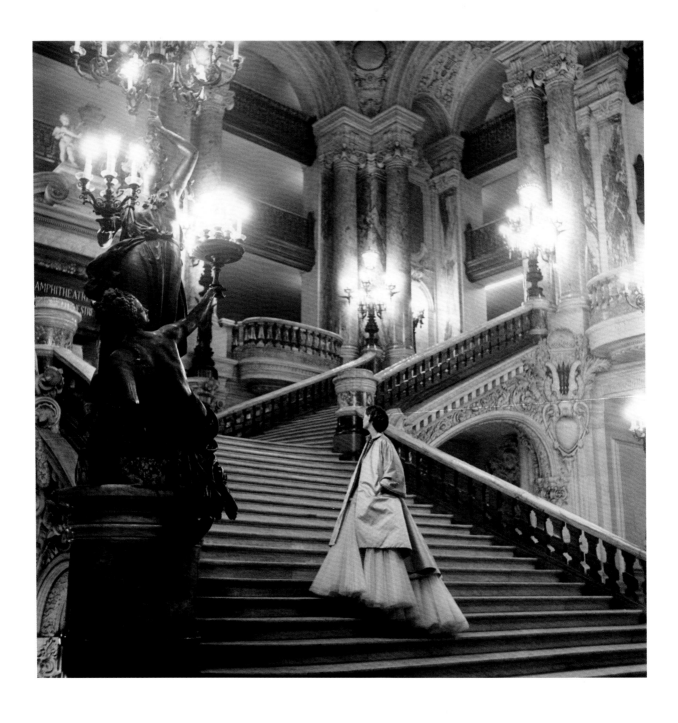

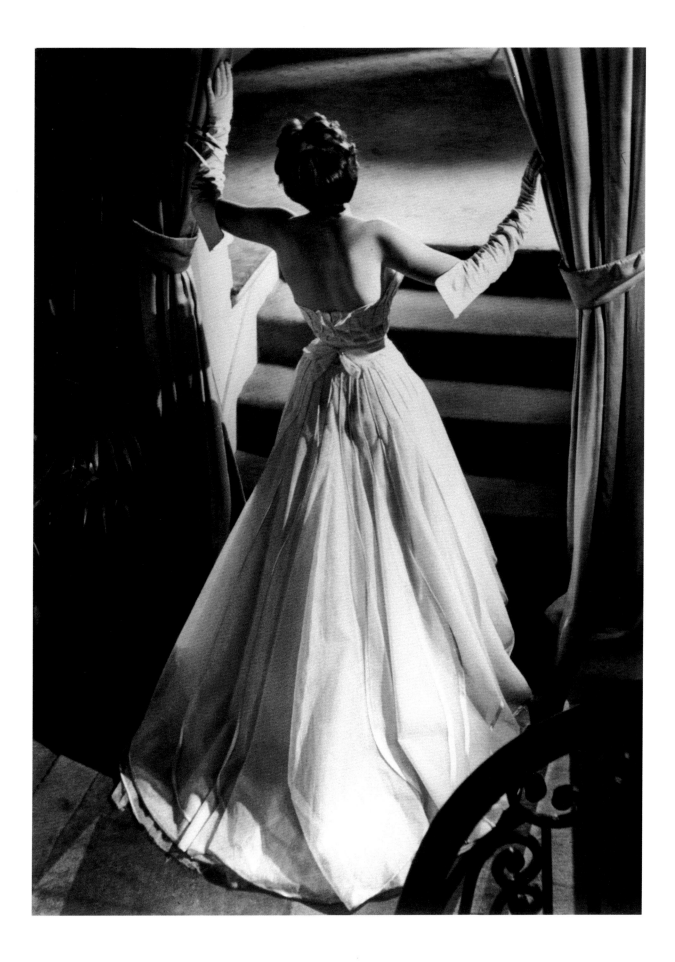

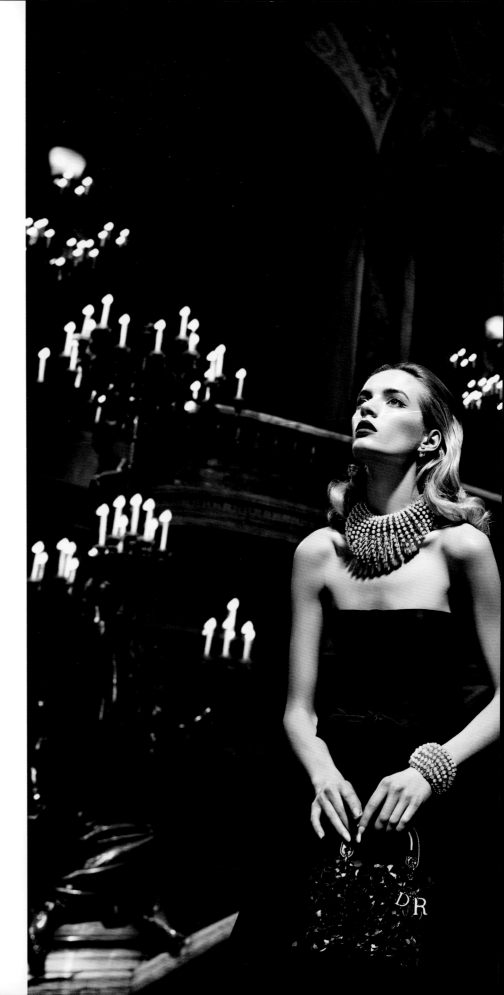

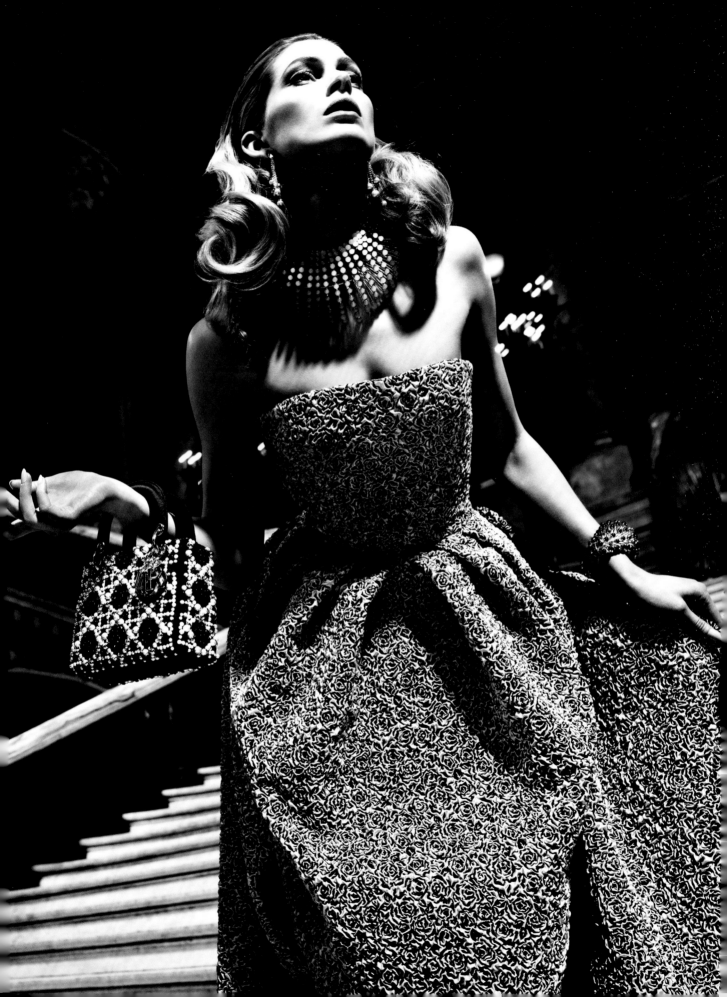

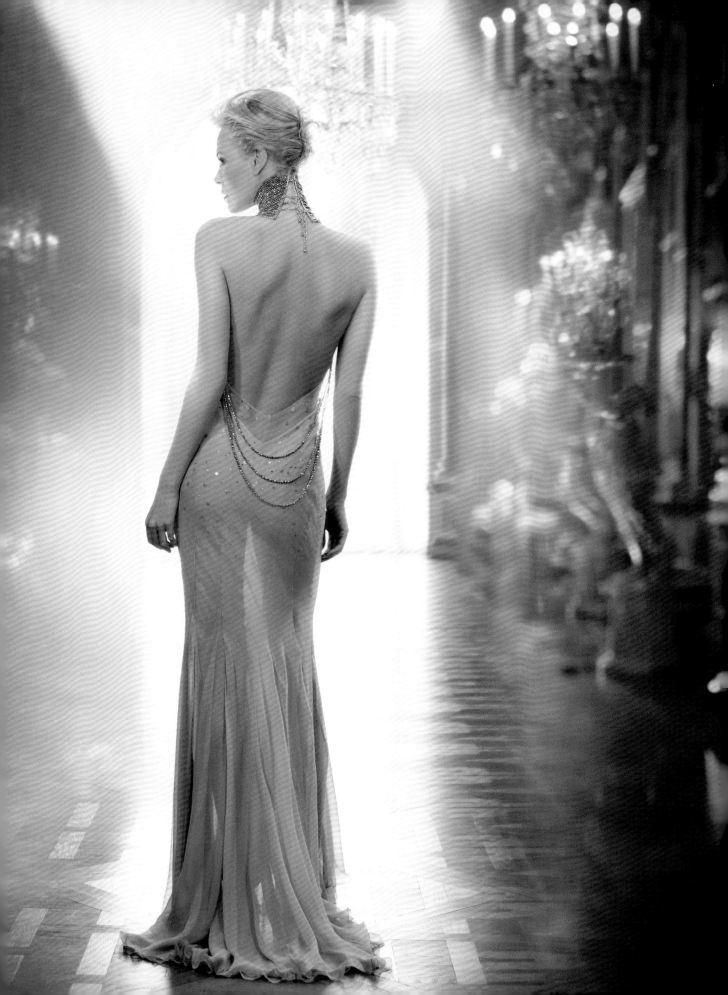

PREVIOUS PAGES
Patrick Demarchelier, 2011. Charlize Theron embodies *J'adore* perfume in the Hall of Mirrors at the Château de Versailles.

OPPOSITE
Norman Parkinson, 1975. In the Queen's Bedroom at the Château de Versailles, Jerry Hall wears a silhouette from the Autumn–Winter 1975 Haute Couture collection.

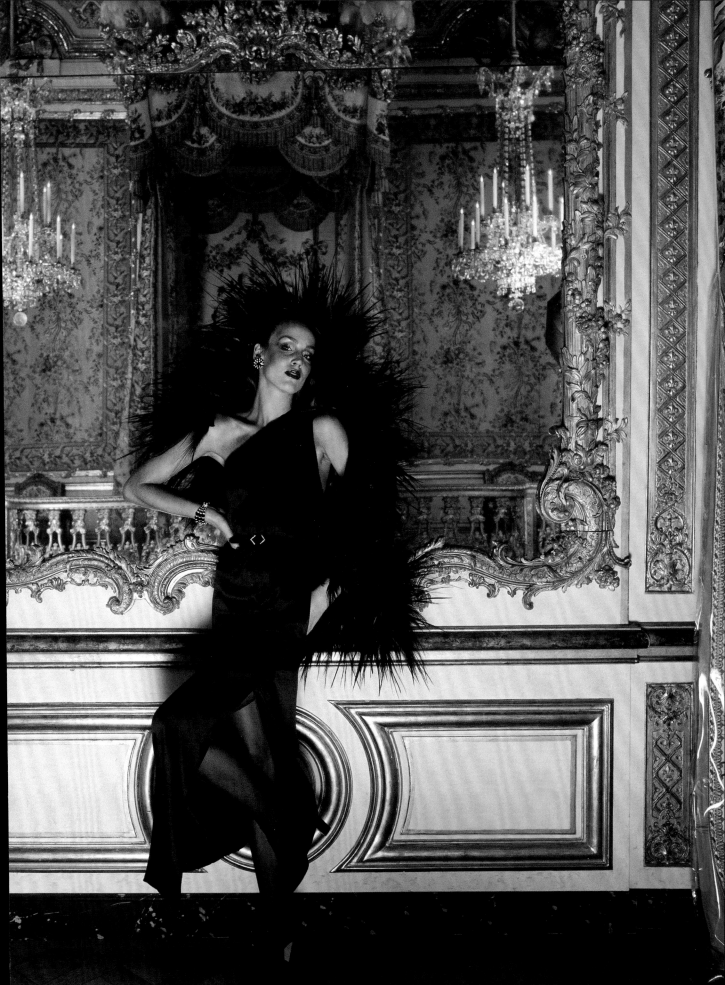

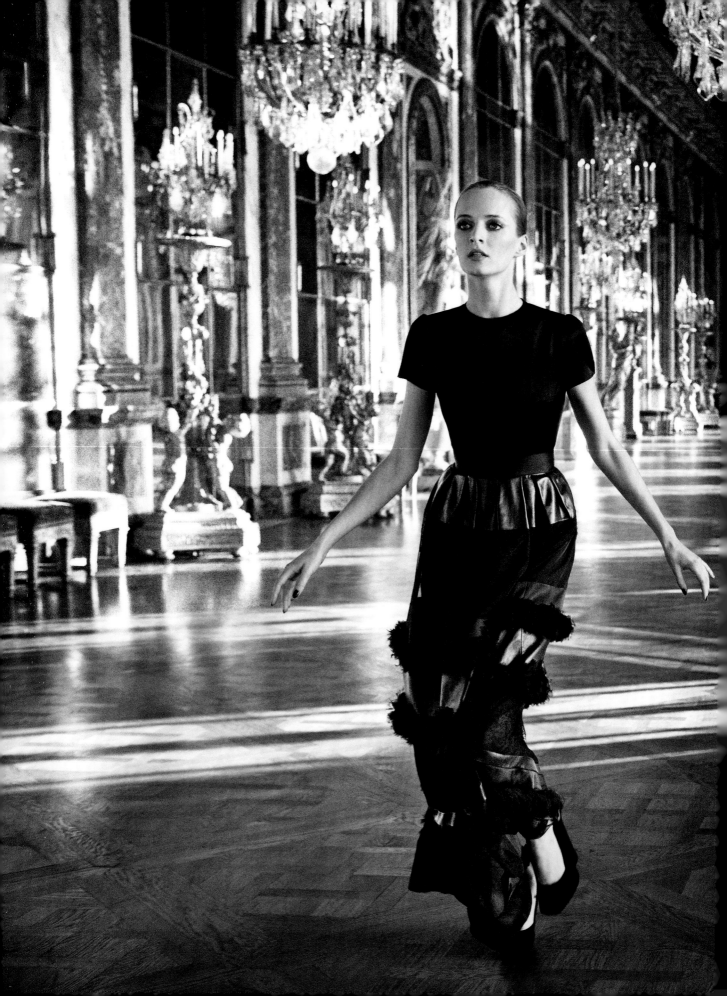

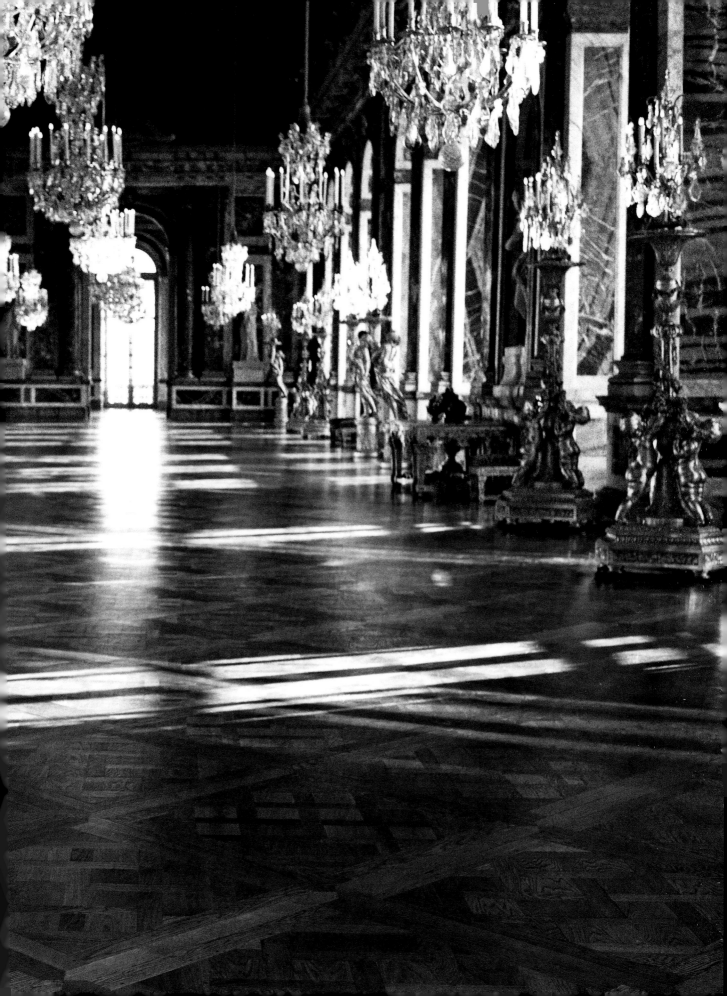

Inez van Lamsweerde and **Vinoodh Matadin**, 2012. Dress from the Fall 2012 Prêt-à-Porter collection in the Hall of Mirrors at the Château de Versailles.

Patrick Demarchelier, 2007. Jacket from the *Ko-Ko-San* silhouette, Spring–Summer 2007 Haute Couture collection.

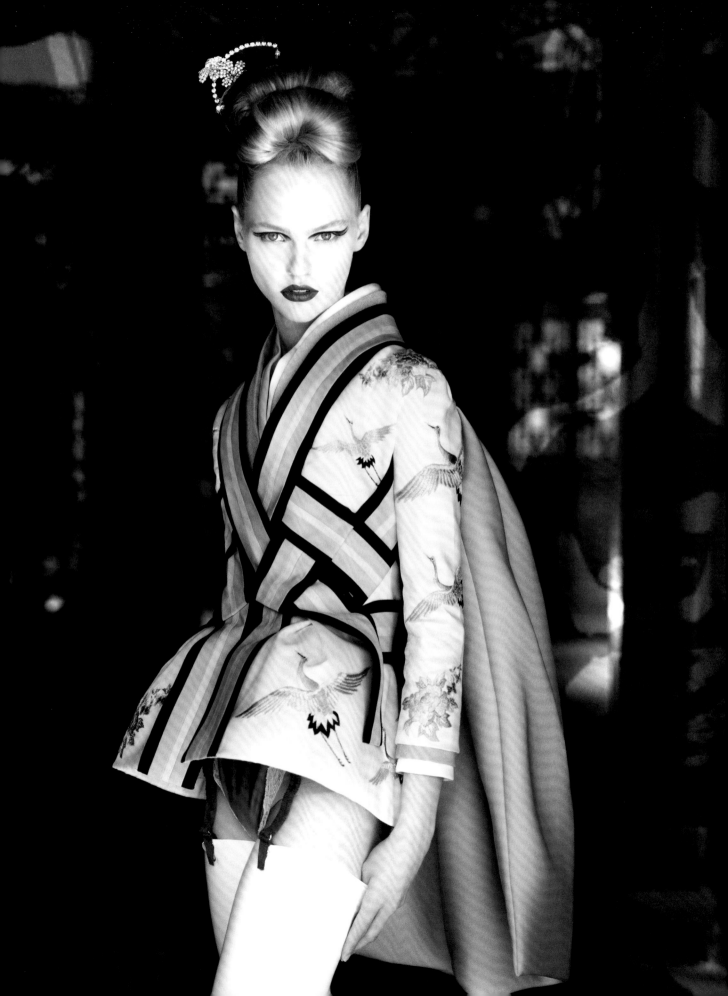

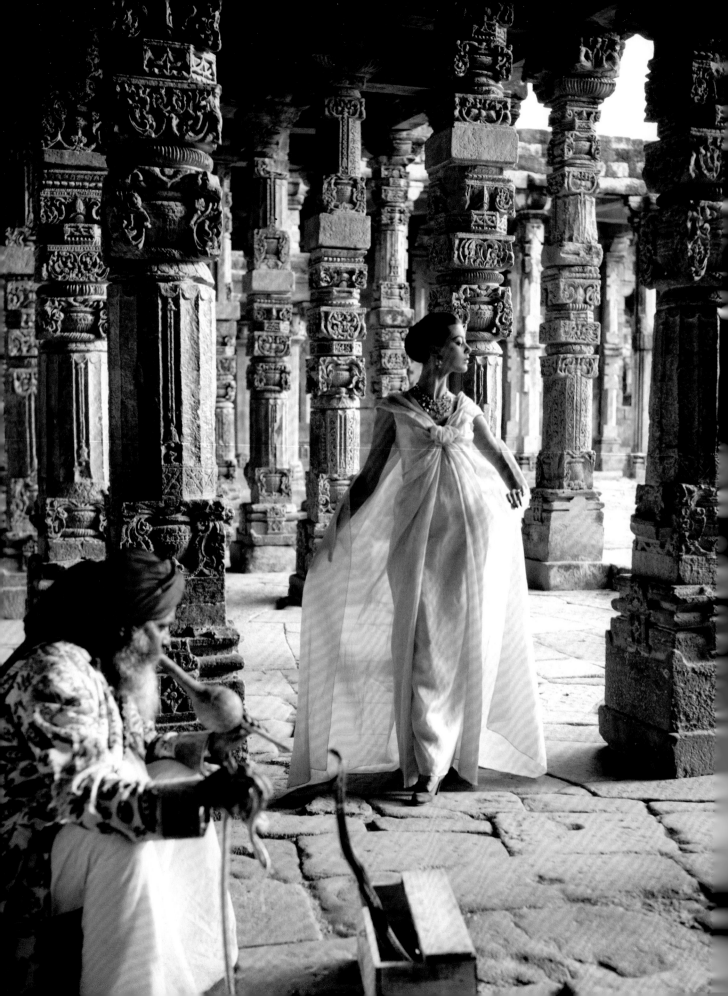

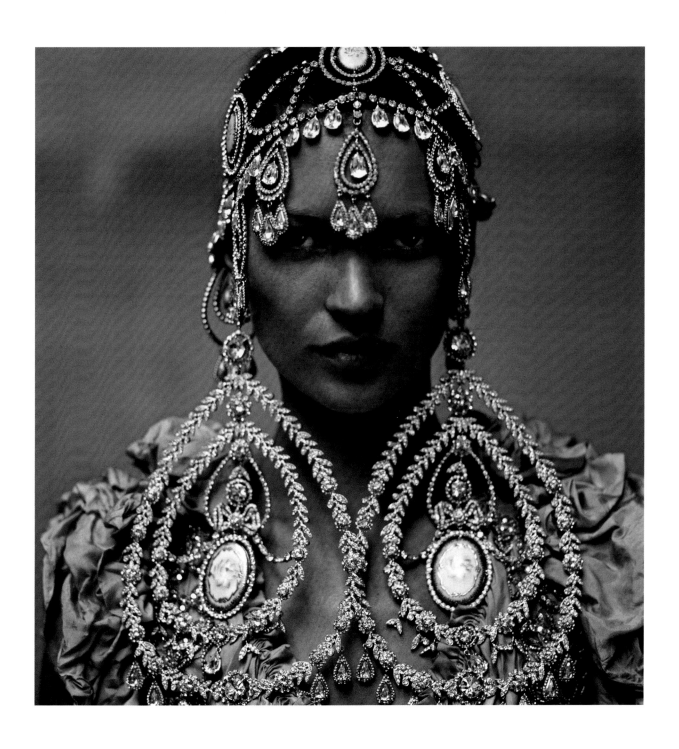

OPPOSITE
Norman Parkinson, 1956. In Quwwat-
ul-Islam mosque in Delhi, dress from the
Autumn–Winter 1956 Haute Couture
collection, *Aimant* line.

ABOVE
Annie Leibovitz, 1999. Silhouette
from the Autumn–Winter 1999 Haute
Couture collection. From the Kate Moss
portfolio, originally photographed for
American *Vogue*.

87

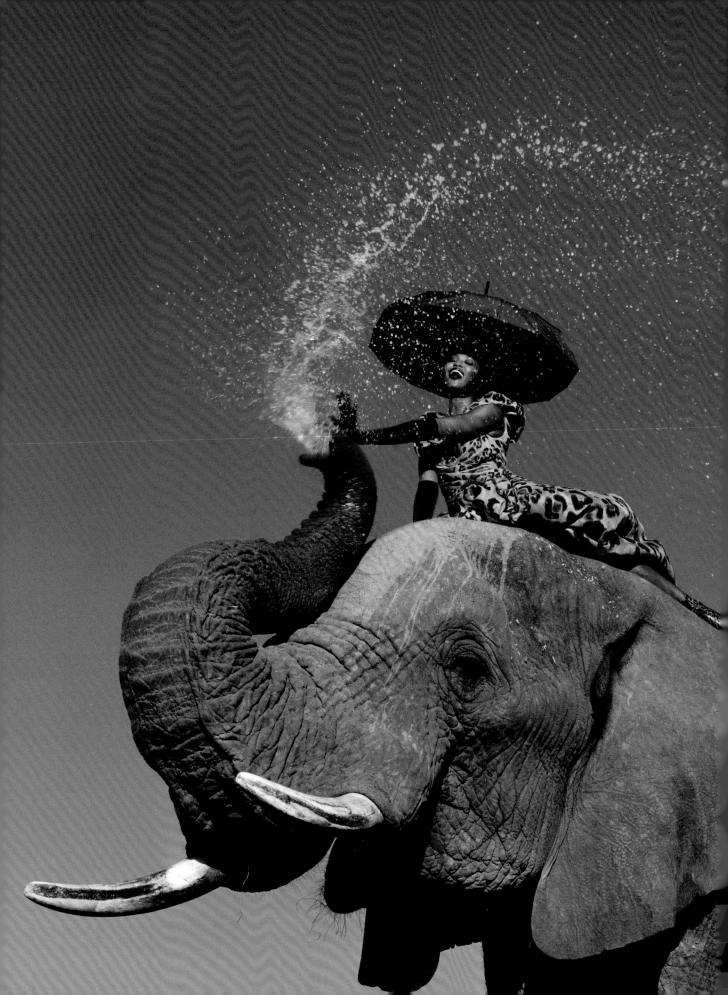

PREVIOUS PAGES
Jean-Paul Goude, 2009. Dress
from the Spring–Summer 2008
Haute Couture collection.

OPPOSITE
Peter Lindbergh, 1997. *Kusudi* and
Kitu dresses, Spring–Summer 1997
Haute Couture collection.

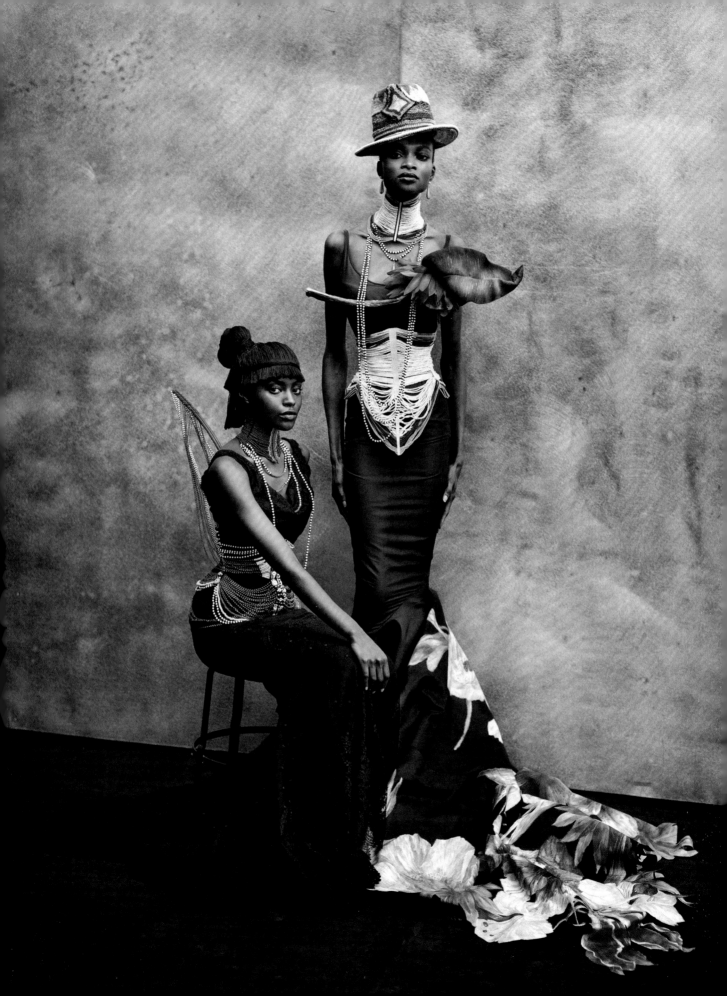

The Photographer and Model at Work
photographed by Regina Relang

Barbara Jeauffroy-Mairet

During the summer of 1953, for the German magazine *Quick*, Regina Relang photographed the French model Bettina wearing the *Grand Mogol* dress by Dior and posing on the place de la Concorde for the American photographer Robert Randall, who worked regularly for French and British *Vogue* in the 1950s. The German photographer loved these kinds of "making of" images, which were relatively rare at the time. Regina Relang studied painting before developing an interest in fashion photography in 1938. She was based in Berlin but often traveled to Paris, which formed the perfect backdrop for her "picture postcard" shots. "Few cities are as photogenic as Paris, with its bistros and café terraces, its tobacconists and bakeries, its nooks and hidden squares and the impressive place de la Concorde," said the photographer.

To protect couture houses from illegal copying, the fashion federation decided to regulate outdoor photo sessions—though this did not stop spies who would later duplicate the outfits from following the photographers and their models. Speed was therefore of the essence. "I was very good at making sure no one had time to see me change," Bettina recalls. "We would either leave the couture house already dressed, or we would have to get dressed in the taxi."

Contrary to today's practices, the shoots involved a very light crew: the photographer, his or her assistant, a fashion editor, and the model, who had to do her own hair and makeup. Bettina excelled in this element. She had started out as a model for Lucien Lelong, where she met Christian Dior shortly before he founded his couture house. She then posed for the greatest names in photography, from Irving Penn to Henry Clarke. With Robert Randall she worked on finding the ideal pose in which to present the Dior dress. Regina Relang captured this moment of complicity in a snapshot.

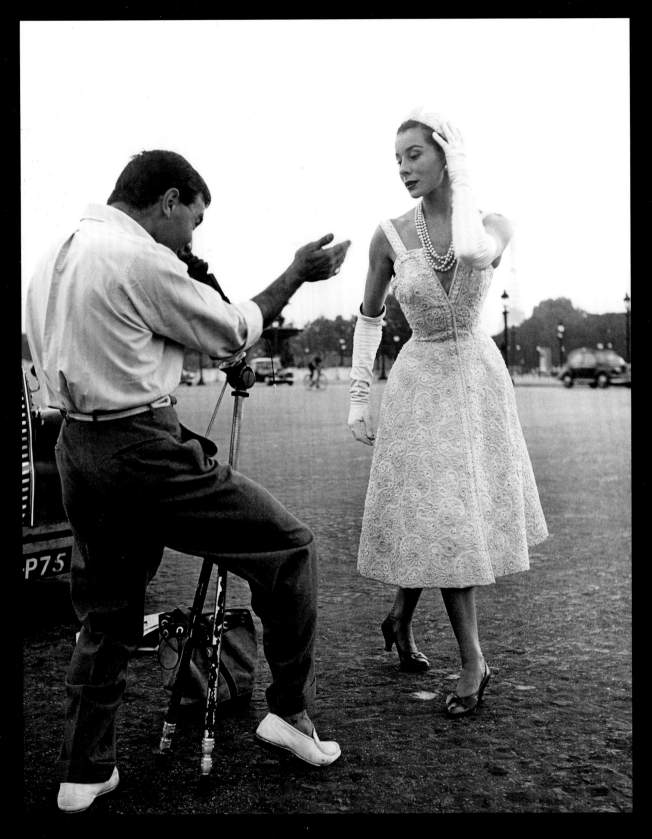

Regina Relang, 1953. Robert Randall
photographs the model Bettina wearing the
Grand Mogol dress, Autumn–Winter 1953
Haute Couture collection, *Vivante* line.

IV

BEAUTY
IN MAJESTY

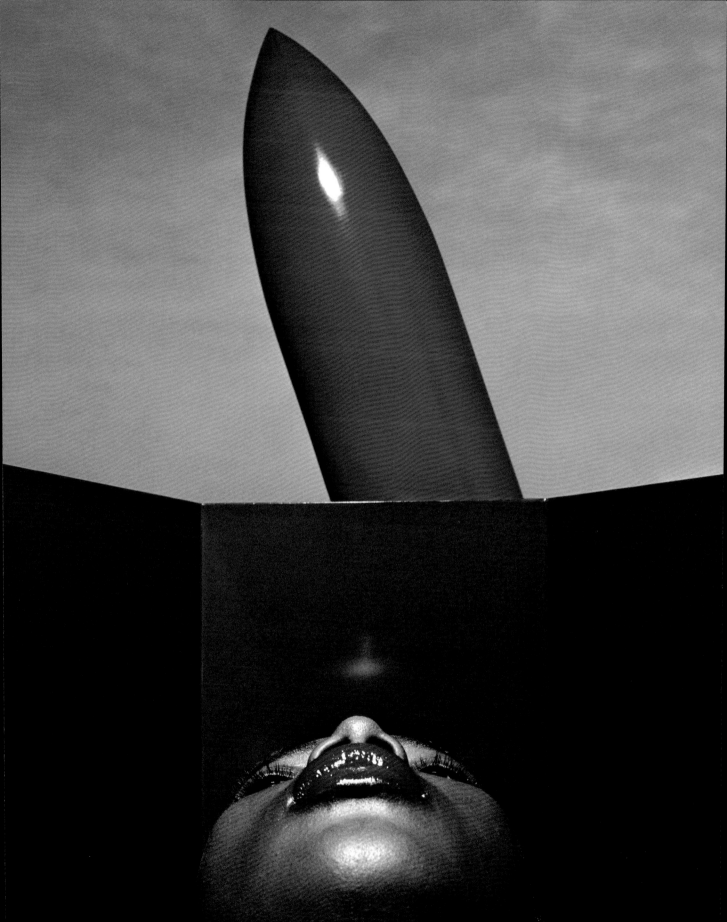

Beauty, Products, Images.
Creating the Sublime.

Farid Chenoune
Fashion Historian

Dior's makeup advertising has been closely connected to its products, beginning with lipstick (1949) and nail polish (1962), depicted primarily in drawings, notably by René Gruau. In 1960 an advertisement for lipstick marked the House of Dior's first use of photography: a black-and-white print by Studio Harcourt, the renowned celebrity portrait studio, portrays a woman's face hidden in the shadow of an elegant dark hat. The oval hat and a sensuous mouth are all that can be seen. This gimmick met with great success in the subgenre of lipstick photography. But the mysterious beautiful stranger it depicts also heralded the advent of advertising photographs liberated from "pack shots," or images of the product being advertised.

Serge Lutens's arrival at Dior inaugurated a new era in photography. Born in Lille, France, in 1942, Lutens discovered the allure of female beauty rituals when he was hired as a trainee hairstylist at a prestigious hair salon, at the age of fourteen. In 1962 he worked in Paris as an assistant at the *Vogue* studio. In 1967 the House of Dior noticed his makeup work: Dior was looking for the color collection that they—and everyone else—lacked. They found it in *Explosion de Couleurs*.

Explosion broke away from the tradition of cosmetic brands, and its advertising campaign sparked a revolution. Inspired by a magazine photo about the Nigerian civil war, the model's makeup covers her face in multicolored stripes like a mask. This was no carnival mask or masquerade but a makeup manifesto. "Women who bought these brash or eccentric eye shadows and lipsticks weren't buying a color, they were buying freedom," Serge Lutens stated.[1] The photographer was Guy Bourdin, whose campaigns for Charles Jourdan shoes would reveal a darkly humorous, fetishistic world. With Serge Lutens he played with surrealism and the spirit of pop art, photographing in 1970 an eye surrounded by multicolored rings like a faraway planet. For Dior, fashion photography provided an imaginary dimension that was now essential to the House's style, full of stories and surprises. From 1969 to 1972, Sarah Moon and Bob Richardson also worked with Serge Lutens. Moon was a former model who shot the melancholy *Naïfs* face in autumn 1969, while Richardson was renowned for photos as snappy as on-the-spot reports and gave the *Très Gais* photo

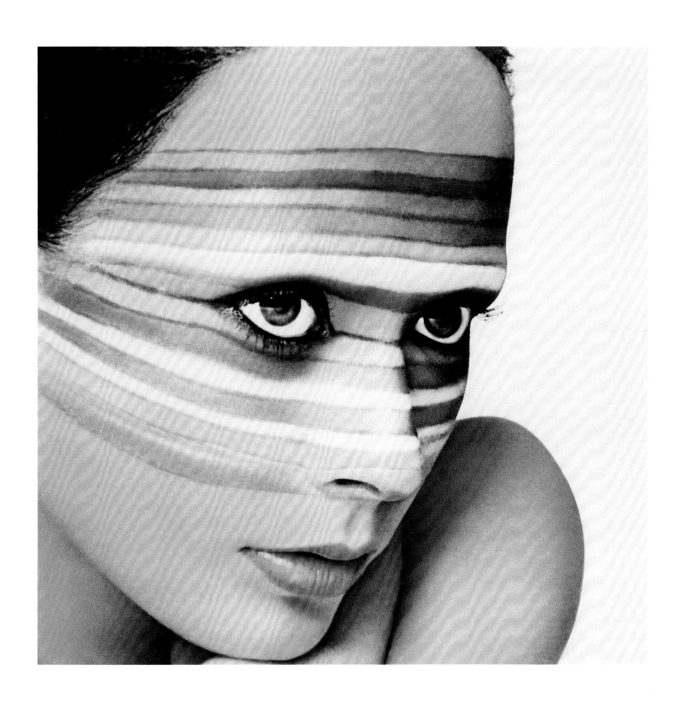

PREVIOUS PAGE
Guy Bourdin, 1972. Dior lipstick.

ABOVE
Guy Bourdin, 1969. *Explosion de Couleurs*
collection, Spring–Summer 1969.

97

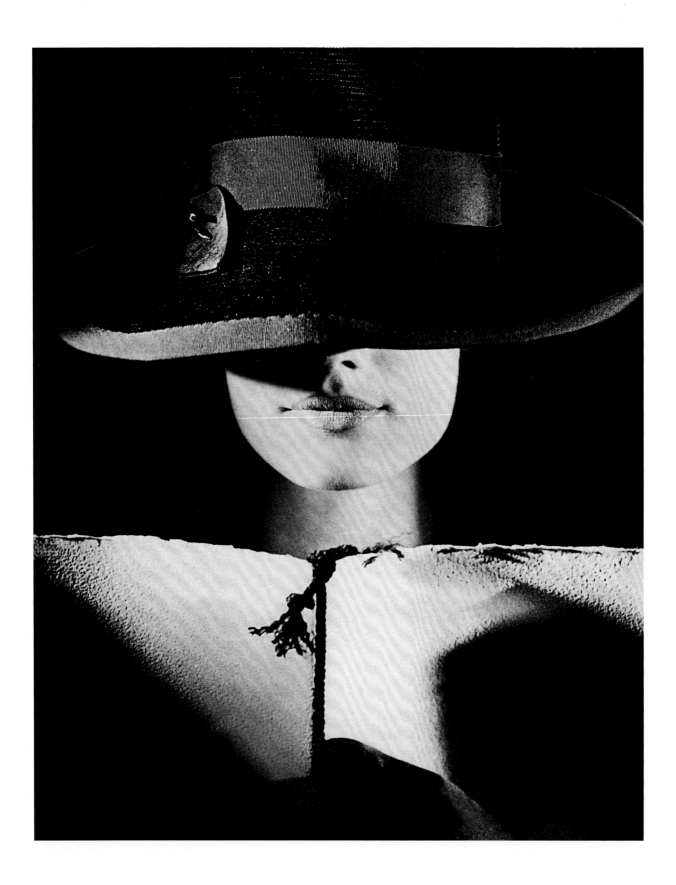

Studio Harcourt, 1960. Dior lipstick.

the feel of a personal document. After 1972, collaborations between Dior and many photographers over a short time ended.

In the spring of 1973, Angelica Huston posed for the *Les Aventureux* campaign. She was a Bonnie without Clyde, dressed in a trench coat, a turtleneck sweater, and a mustard-colored beret, with painted lips and nails, smoky eyes under a jet-black fringe of bangs, as she smoked a cigarette at the window of a train. The photograph was by Serge Lutens. Things had changed in the previous few months. Serge Lutens had "done" colors: two collections a year with themes that he defined and named (these would soon be known as "looks"). Now he was also "doing" images, as a photographer.

The makeup took hours, the makeup artist whitening the face before "drawing the ideal character on it," an ethereal and inaccessible figure. Serge Lutens talked little, communicating more with his hands. These shoots united the model and the photographer. The music—sacred and profane, from Bach to Fréhel—was "the amniotic liquid" between them.[2] Yvonne Sporre, one of Lutens's models, gave a gripping account of these sessions: "His vision of beauty meant I had to be annihilated in a way, until the lightest breath, the slightest movement, and practically every pore of my skin had become his territory, his domain."[3]

Though sometimes roundly disliked, Serge Lutens's artificial-looking, enigmatic heroines peopled countless department stores and perfumeries. Their pale, mysterious faces fit with his almost obsessive casting plan, "the eyes almost popping out of the head," Lutens explained, "rather 1930s." He capitalized on this advertising success to continue to assert the boldness of Dior, where "eccentricity was a culture" that nobody feared,[4] until Lutens left the House, in 1979.

Tyen has created the makeup at Christian Dior since 1980. He was born in Vietnam and arrived in Paris at the age of sixteen, where he studied at the École des Beaux-Arts and spent six years working as a makeup designer at the Opéra de Paris. This led him to American *Vogue* and *Vanity Fair*, working with Richard Avedon, Irving Penn, and Arthur Elgort. In charge of "colors" at Dior, in 1982 he created *Neige de Lune*, a four-color eye-shadow palette, and in 1984 came up with a best-selling electric-blue mascara. Just as Serge Lutens had teamed up with Guy Bourdin in his early years, Tyen formed a duo with Paolo Roversi. The Italian photographer brought out the elegant, evanescent femininity in his models, underscored with colored lines as mystical as an aura. Following this experience, Tyen was put in charge of makeup, as Lutens had been, along with perfumes as well, such as *Poison*, in 1985. His first campaign as a photographer started in autumn of 1983 with *Feux Follets*.

Femininity is a thread running throughout the Tyen era. His vision of femininity turns away from Serge Lutens's creatures to blossom into a kind of balanced beauty—an

unaggressive, glamorous sensuality tinged with soft mystery that sparks dreams and desire more than threats and anxiety. Emmanuelle Béart was wild for *Les Ténébreuses* in 1998, Monica Bellucci cut a regal figure in *Rouge Dior* in 2006, and Natalie Portman was a natural for *Diorskin Forever* foundation in 2011: choosing actresses over models to be the face of a product was dictated by this return to the traditional dreaminess to which fashion—and Dior—lay claim.

Light is the raw material in Tyen's photographs: it was in his opera work that he discovered how it adds three-dimensionality to a face. He reminds us to never forget that a glossy photo needs an expression to bring it to life, whether from the eyes, the position of the fingers, slightly parted lips, or a discreet turn of the neck. According to Tyen, light is like a "second skin." It mixes shadows, vanishing points, and lines in its glare, with faces often framed in three-quarter shots. When the photograph is as powerfully evocative as a silent film, it works.

Tyen has produced a considerable amount of work since 1983, with a large number of lines, products, and events to highlight. These new images, referred to as "visuals," have a makeup iconography that echoes the Dior Haute Couture collections and has opened up to other photographers, who bring new moods and new styles of femininity. In spring 2002, Nick Knight's work for the *Manga* campaign was shot with explosive energy. In spring 2009, the *New Look* collection was shot by Craig McDean, who is known for his true-to-life portraits of famous faces. In 2010, David Sims photographed a very 1960s, doe-eyed Kate Moss for *Dior Addict* lipstick. In 2012, Mert Alas & Marcus Piggott lit up Natalie Portman for the *Diorshow New Look* mascara. In 2013, Steven Meisel choreographed Daria Strokous's face and hands for the *Mystic Metallics* look. This new lineup of photographers is also illustrated in spectacular perfume campaigns such as *Dior J'adore*, with Carmen Kass shot by Jean-Baptiste Mondino in 1998, and Charlize Theron, shot by Nick Knight in 2004, by Mondino (several times), and then by Patrick Demarchelier since 2011. The result is a collection of luxurious images that belong to the great Dior canon, at the crossroads between visuals and visions.

[1] Serge Lutens, series of five radio interviews with Philippe Bresson in *A voix nue*, France Culture, September 2–6, 2013.
[2] Ibid.
[3] *Encens*, n° 27, 2012.
[4] "Serge Lutens, perfume creator" (unpublished interview, Parfums Christian Dior archives, n.d.).

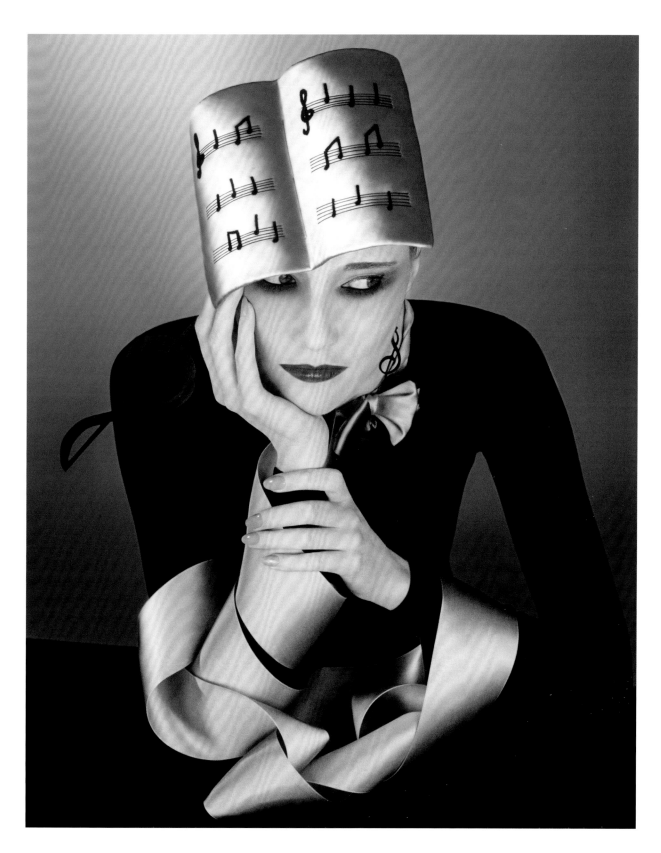

"A musician's ear will recognize that no score
has ever been so well played! Music by Gershwin.
Blue rhapsody in beige." **Serge Lutens**, 1979.
Les Rythmiques collection, Spring–Summer 1979.

"If it hadn't been for the summer, the southern
Ardèche and myself during that dreadful period
they call 'holidays,' which had me stamping this
imaginary flamenco with impatience, this hat
made up of glued and painted cardboard would
not have echoed my Spain." **Serge Lutens**, 1974.
Les Carmins collection, Spring–Summer 1974.

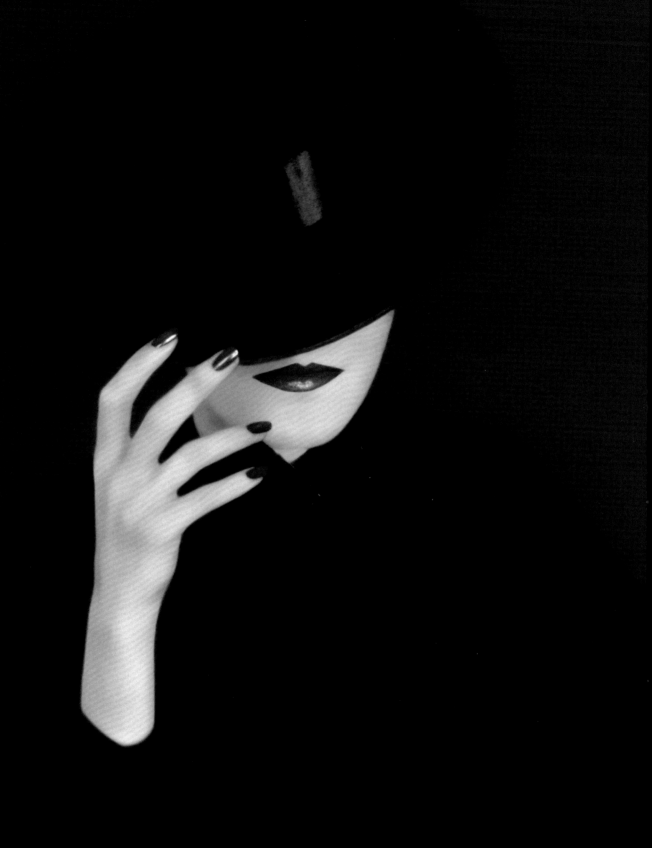

"I like the things that make beauty sublime, a flaw in the perfection. Sometimes I like two or three flaws in the shapes: a mouth a bit too thick, a nose a bit too long, a small imperfect detail . . ." **Tyen**, 1997. *Diorific* lipstick.

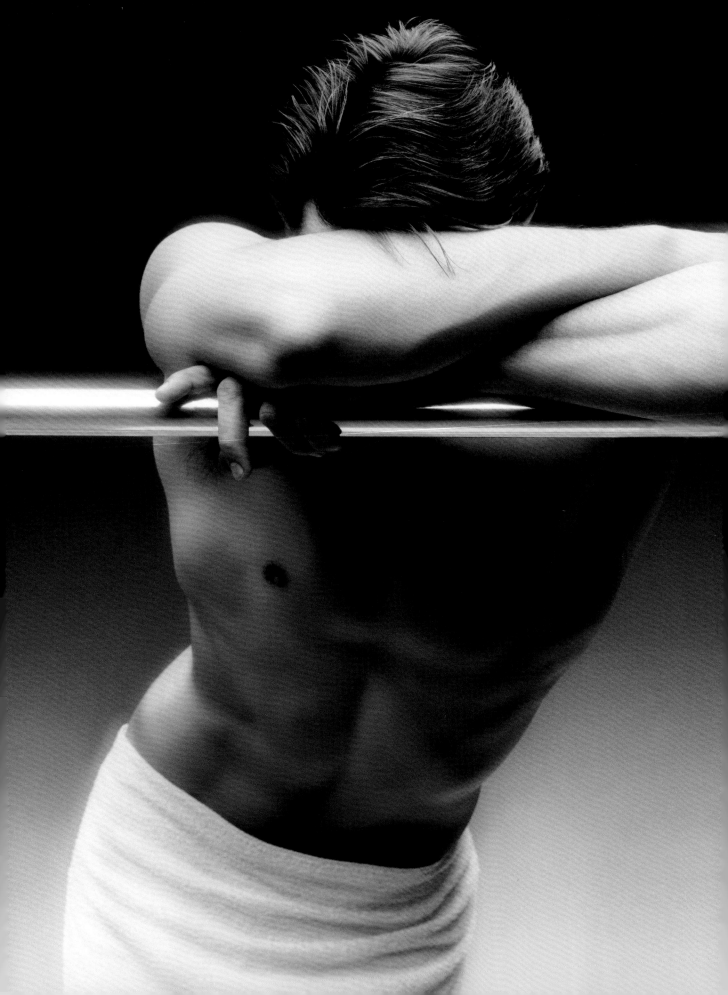

"I took the realism of the photo and made something very pictorial, graphic, and stylized." **Dominique Issermann**, 1987. *Eau Sauvage* fragrance.

Robert Pattinson
photographed by Nan Goldin

Barbara Jeauffroy-Mairet

1000 Lives, the Dior Homme film directed by Romain Gavras and starring Robert Pattinson as its hero, premiered in September 2013. A road movie that takes place between New York City and the shores of Long Island, it follows a man reminiscent of a modern-day James Dean and a young woman living their life and their love to the fullest, embodying Dean's advice to "dream as if you'll live forever. Live as if you'll die today." Best known for her shots of the New York underground in the 1980s, Nan Goldin followed the actor on set, shooting up close to capture his seductive power, whether in a hotel room, on a beach, or in the turquoise waters of a swimming pool. These are the kinds of intimate scenes preferred by Nan Goldin, whose work generally portrays an uncompromising vision of everyday life, mundane yet tragic. This series of photographs shows her world straightforwardly and establishes a distinctive concept of raw masculinity. Virility meets sensitivity to create a uniquely intense charm in this portrait of Robert Pattinson, head bowed as though lost in thought. To highlight the actor's youth and sensitivity, Nan Goldin drew inspiration from a portrait by Luigi Lucioni, *Paul Cadmus*, painted in 1928: "The same light brown hair, the same blue eyes—Robert has something of this guy in him." She also made a rare foray back to some of her emblematic shots, such as *French Chris on the Convertible, NYC*, taken in 1979, in order to "find that same virginity, the same grace."

V

SOVEREIGN
STYLE

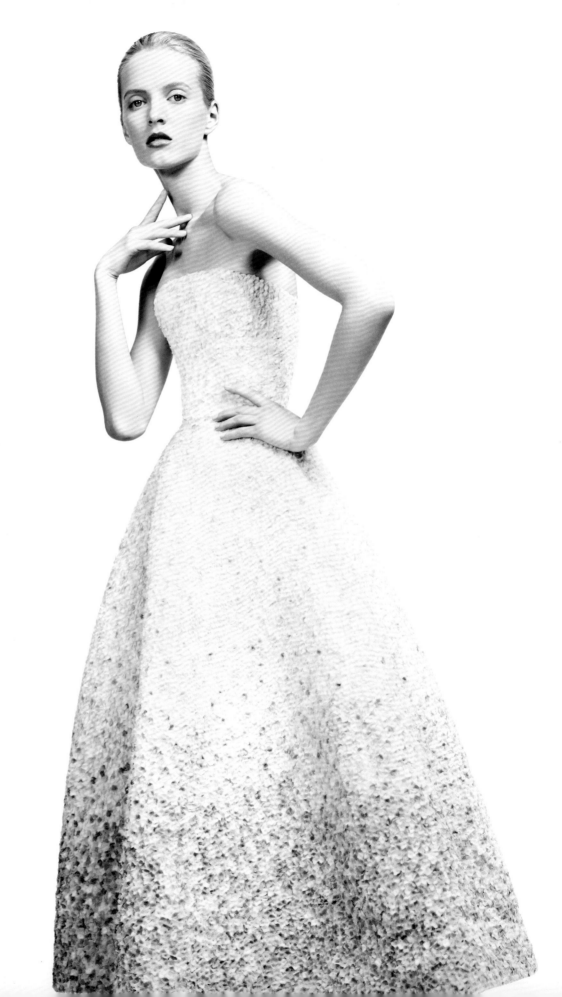

From Dress to Photograph: Constructing the Image

Florence Müller

The different stages that go into constructing the Dior image have evolved over time, but some characteristics do not change. One is the fact that a photo session is like a film shoot, orchestrated by a host of professionals around a director-photographer.

The fashion shot is a link between Dior and the magazine reader. It starts where the fashion show ends. In the old days, shoots were often held at night, once the last buyers had gone. The House of Dior sent out the dresses wrapped carefully in tissue paper and packed in cardboard boxes. The magazine was not allowed to change the "total look" loaned by the couturier. The session was organized to suit the photographer's desires, using the decor and hair and makeup artists he wanted. "Photographers were treated like stars," Michèle Zaquin recalls.[1] Their gentlemanly stature went well with their dominant position in the fashion press. Lord Snowdon, Sir Cecil Beaton, and Norman Parkinson were worldly men with natural presence. Richard Avedon, Guy Bourdin, and Helmut Newton had the power to exert total control over their publications in magazines. Avedon and Bourdin would make sketches to compose the photos as they would appear on the page. Each magazine had its own style and readership. *Elle* models were very different from *Vogue* girls. French *Elle*'s editor-in-chief Hélène Lazareff told her art director Peter Knapp, "I want women you'd like to have dinner with!"[2] It was a reminder that the models had to represent the exemplary social values of the magazine. At *Vogue*, meanwhile, the fashion statement and aesthetics came first.

The photographers were split into two families: those who preferred studios, like Irving Penn or Horst P. Horst, and those who would rather use exterior shots, like William Klein or Helmut Newton. *Vogue* and *Harper's Bazaar* had their own studios in Paris, London, and New York. Nancy Hall-Duncan has said that *Vogue* was "the equivalent of a Hollywood studio where 'star' photographers could get anything they wanted, build the most extravagant sets, use the most exotic accessories and earn a lot of money."[3] Irving Penn preferred the Studio Astre on rue Saint-Dominique over *Vogue*'s in-house location. He demanded that all the sets be reserved for him and imposed absolute silence so that he could concentrate. But most *Vogue* photographers chose to work in the magazine's premises at 4 place du Palais Bourbon.

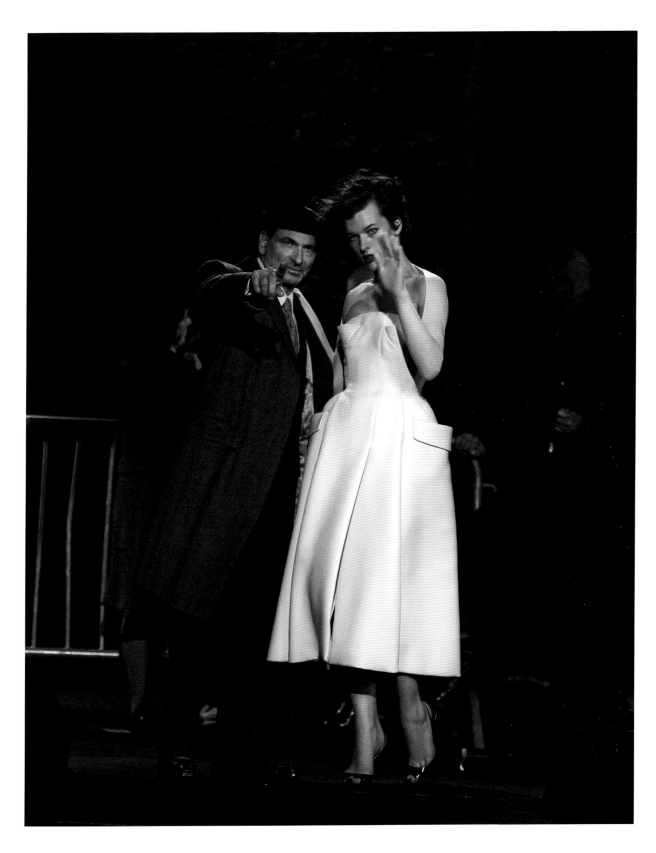

PREVIOUS PAGE
Willy Vanderperre, 2012. Evening
dress from the Autumn–Winter 2012
Haute Couture collection.

ABOVE
Peter Lindbergh, 2012. Milla Jovovich
wears a day dress from the Autumn–Winter
2012 Haute Couture collection.

115

Nick Knight, 2012. Day dress from the
Autumn–Winter 2012 Haute Couture collection.

For many years, Paris was the foremost setting for exterior shots. Then, from the 1960s on, the expansion of foreign travel had photographers venturing into new territories. Henry Clarke and Norman Parkinson were among the first traveler-photographers. Clarke teamed up with *Vogue* editor Susan Train in North Africa and Asia. Franco Rubartelli and Veruschka traveled without a crew. David Bailey took Penelope Tree to Hawaii and South America.

Once the shoots were finished, the art director chose the photos, sometimes with the photographer's participation. The selection was made from work prints, then using simple contact sheets, for economy's sake. The photos were mounted on card at layout stage. For *Vogue*, Alexander Liberman looked for genuine artistic flair. At *Harper's Bazaar*, Alexey Brodovitch gave photography due importance within the dialogue of double-page spreads. When Peter Knapp joined *Elle* he revolutionized the layout by getting rid of the "template" and telling his graphic designers to work freely on a white page, with no guide.

The same stages go into creating a fashion photo today: choosing the outfits, the photographer and the models, doing the shoot, mounting the layout, and so on. But fashion's international dimension, the development of fashion styling, and the digital revolution have changed everything. Shoots take place constantly all over the globe. Digital photography blurs the border between fiction and reality. Fashion's imagination is amplified by the numerous possibilities of the virtual world. The fashion editor asserts her role as a stylist, a position that appeared in the 1970s and became increasingly important in the 1990s and 2000s. She composes combinations of clothes, accessories, hair, and makeup that are fabulous at communicating the fashion message. Diana Vreeland, the pioneer of fashion styling, paved the way for Grace Coddington, Alexandra White, Carine Roitfeld, and Carlyne Cerf. The editor also signs off on the fashion series and is now credited alongside the photographers. But the photographer is still an all-powerful figure, expected to come up with a unique image that will leave its mark on our minds and set the tone for new fashion.

[1] Interview with Michèle Zaquin (joined Condé Nast in 1964,
 Production Manager from 1974 to 2007), December 12, 2013.
[2] Interview with Peter Knapp, December 12, 2013.
[3] *Histoire de la photographie de mode*, Nancy Hall-Duncan,
 preface by Yves Saint Laurent (Paris: Editions du Chêne, 1978), 12.
 Published in the United States as *The History of Fashion Photography*
 (New York: Alpine Books/International Museum of Photography, 1979).

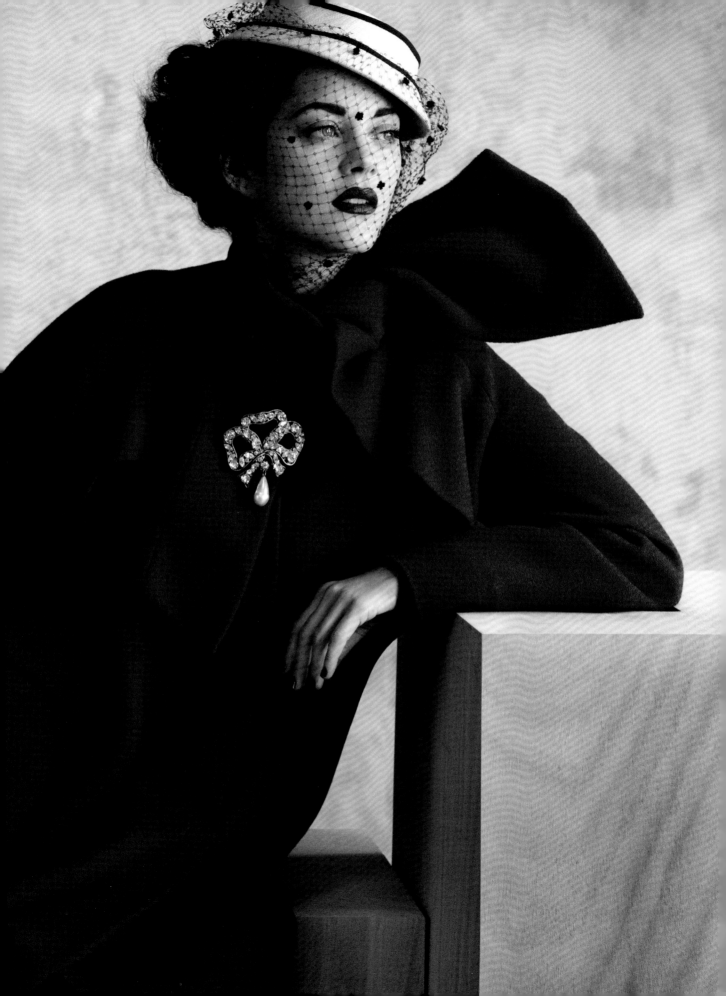

PREVIOUS PAGES
Jean-Baptiste Mondino, 2012. Marion Cotillard wears the *Arizona* coat, Autumn–Winter 1948 Haute Couture collection, *Ailée* line.

OPPOSITE
Mario Sorrenti, 2013. *Arizona 1948* coat, Autumn–Winter 2013 Prêt-à-Porter collection.

The *Arizona* coat created by Christian Dior is emblematic of the *Ailée* line and was reinterpreted by Raf Simons for his second Prêt-à-Porter collection.

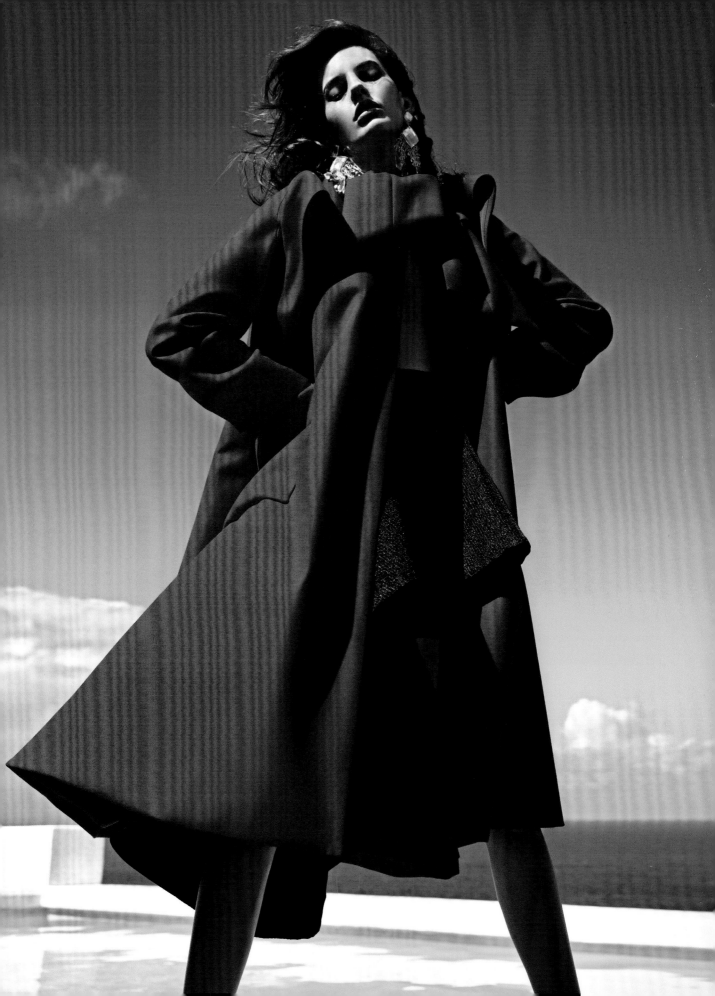

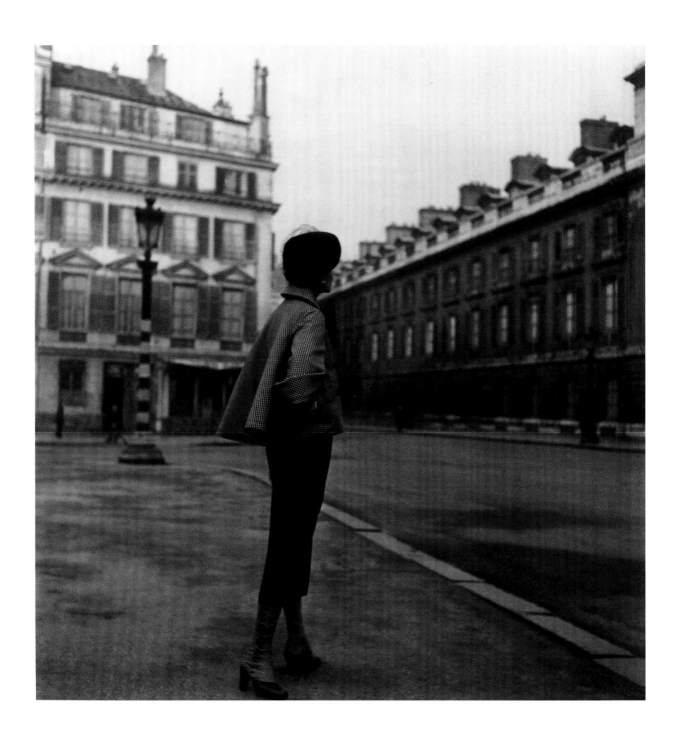

Clifford Coffin, 1948. *Aventure* ensemble, Spring–Summer 1948 Haute Couture collection, *Envol* line.

Patrick Demarchelier, 2011. *Aventure* ensemble, Spring–Summer 1948 Haute Couture collection, *Envol* line.

Nick Knight, 1997. Dress from the Autumn–Winter 1997 Prêt-à-Porter collection.

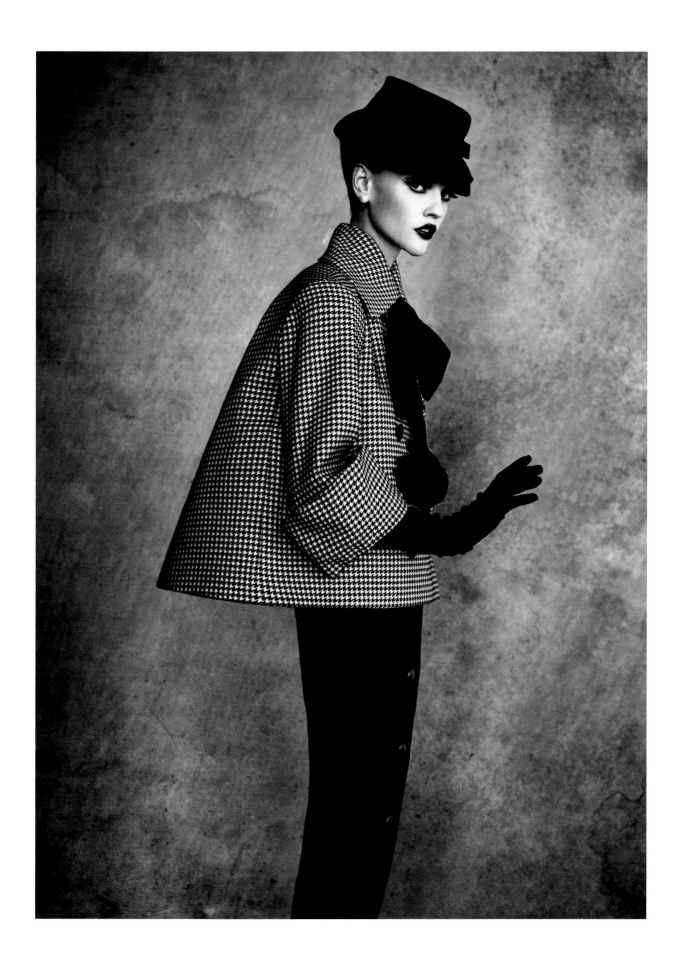

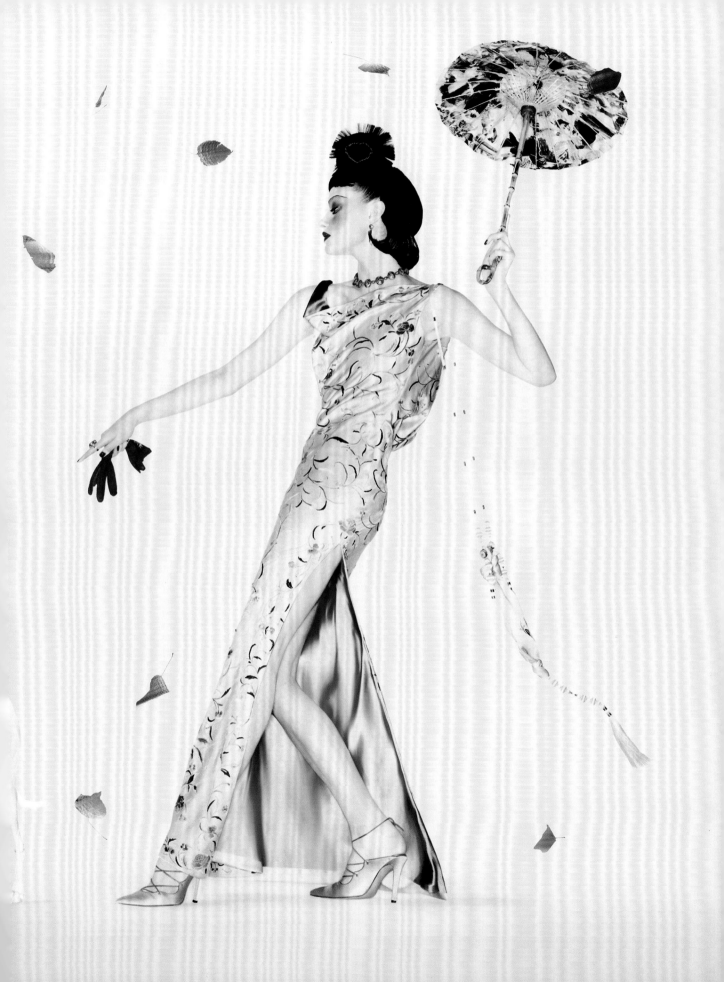

Ruth Hogben, 2012. Evening ensemble from the Autumn–Winter 2012 Haute Couture collection.

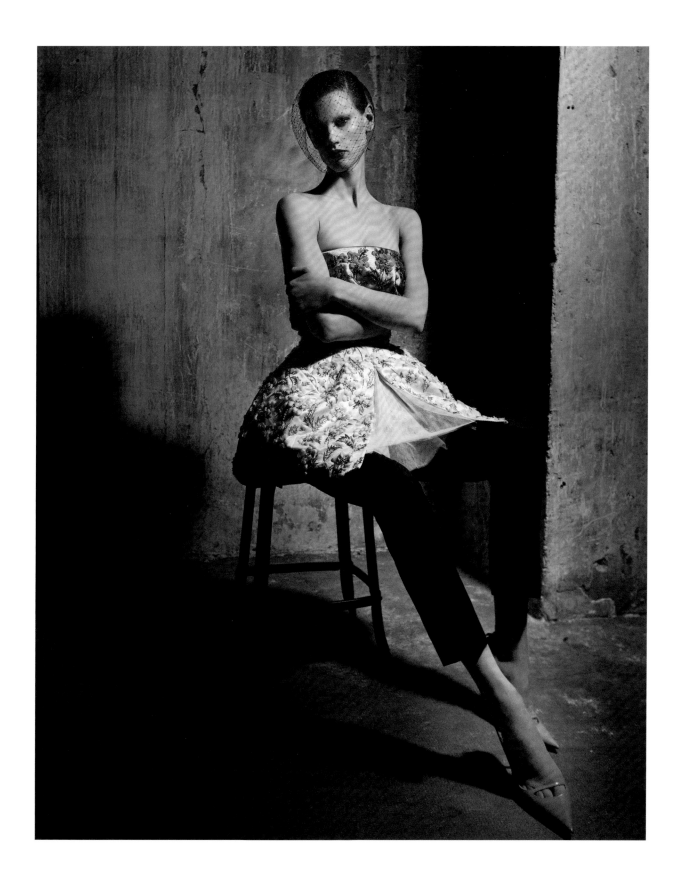

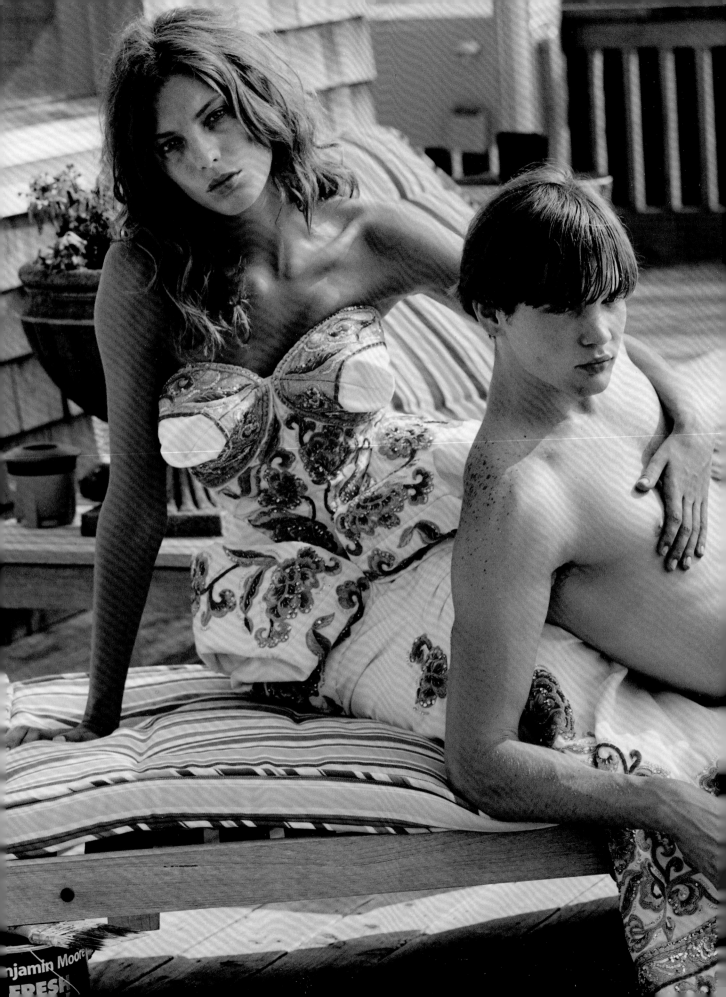

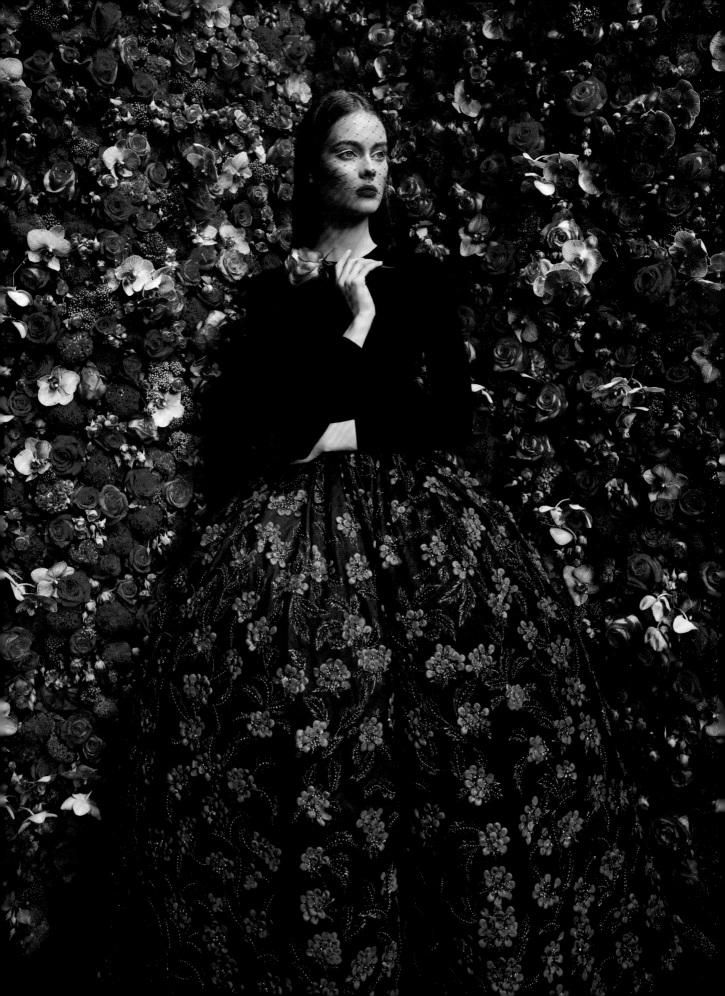

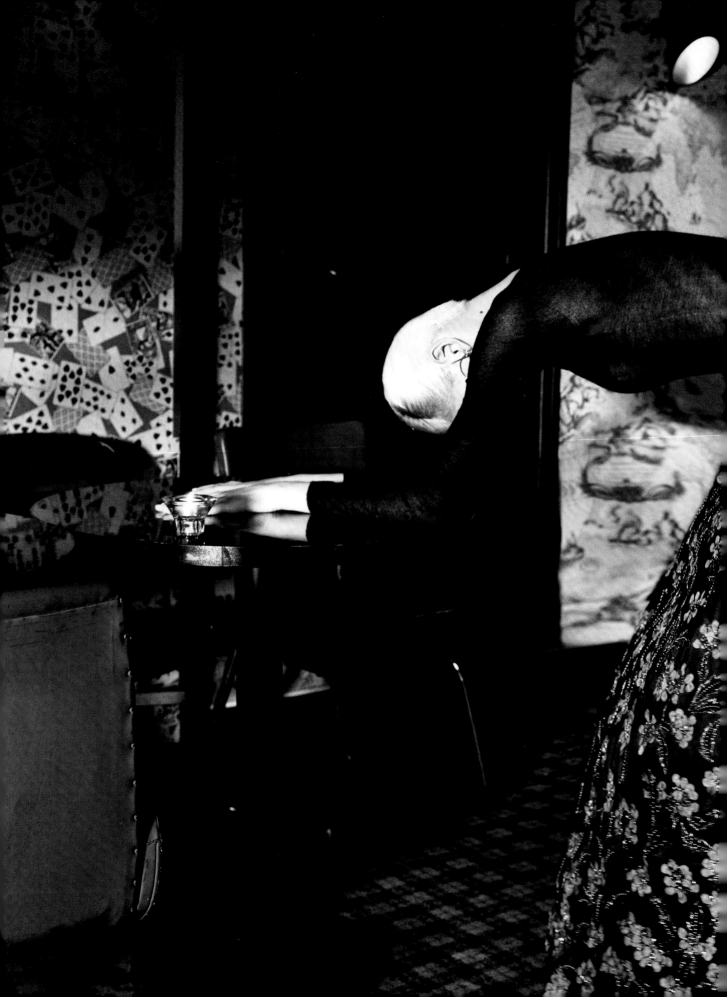

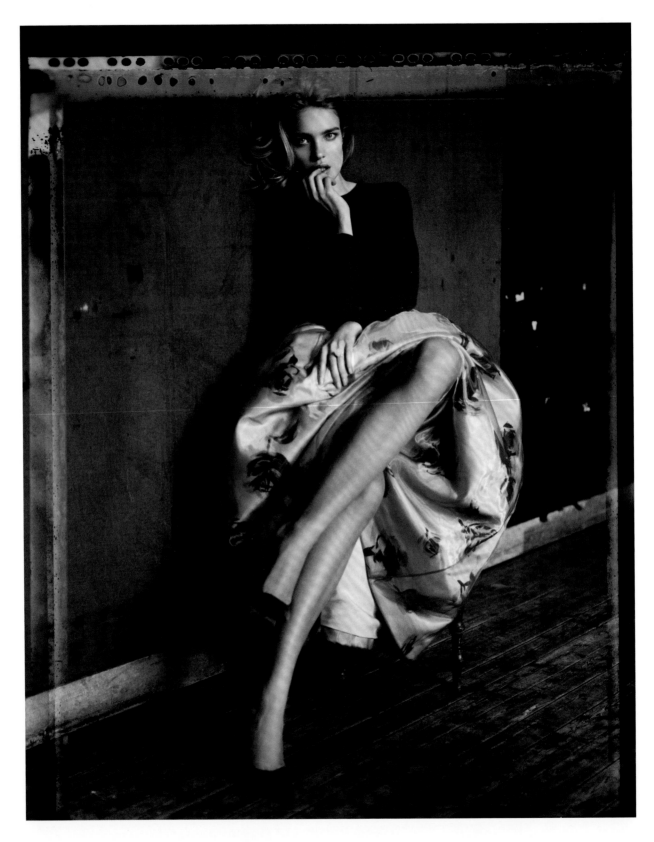

ABOVE
Paolo Roversi, 2013. Natalia Vodianova
wears a silhouette from the Spring–Summer
2013 Prêt-à-Porter collection.

OPPOSITE
David Sims, 2013. Spring–Summer
2013 Prêt-à-Porter collection.

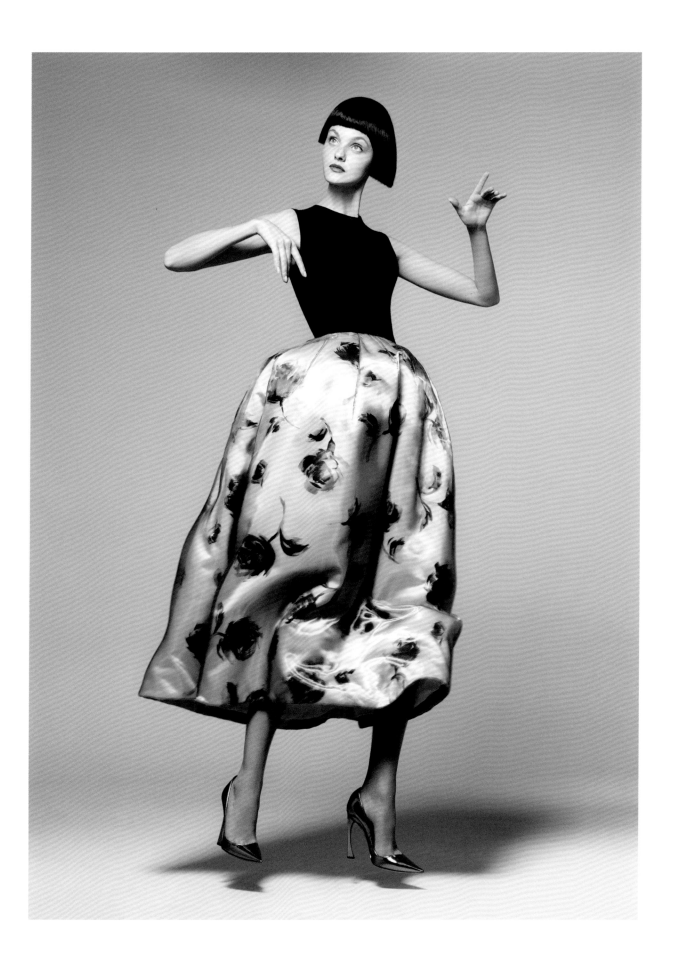

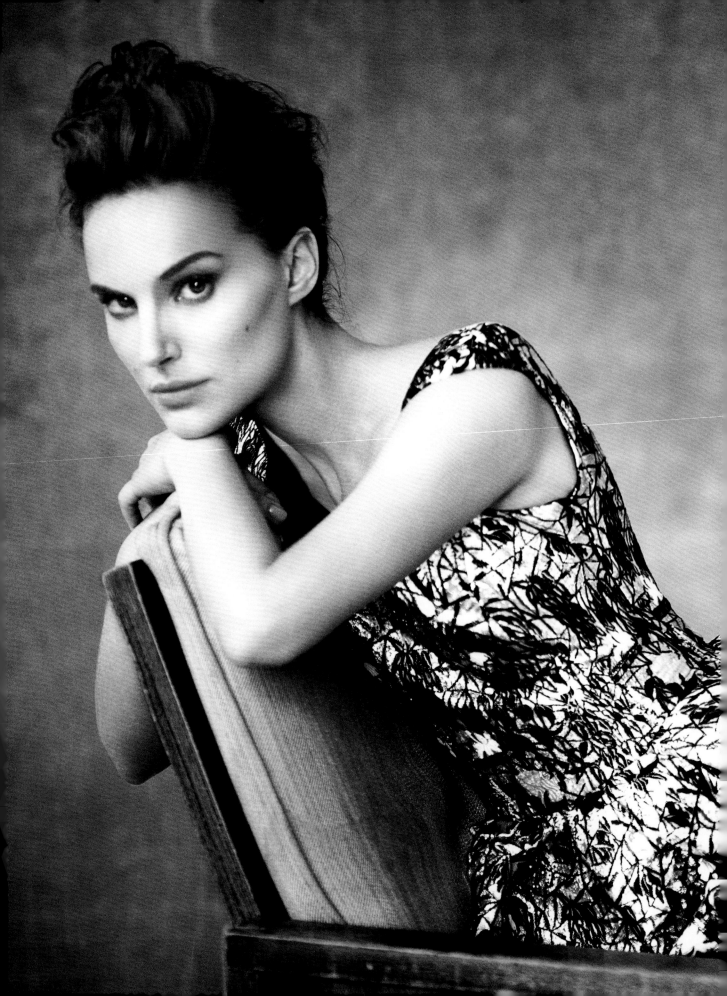

PREVIOUS PAGES
Paolo Roversi, 2013. Natalie Portman wears a silhouette from the Spring–Summer 2014 Prêt-à-Porter collection.

OPPOSITE
Lillian Bassman, 1949. *Miss Dior* dress, Spring–Summer 1949 Haute Couture collection, *Trompe-l'œil* line.

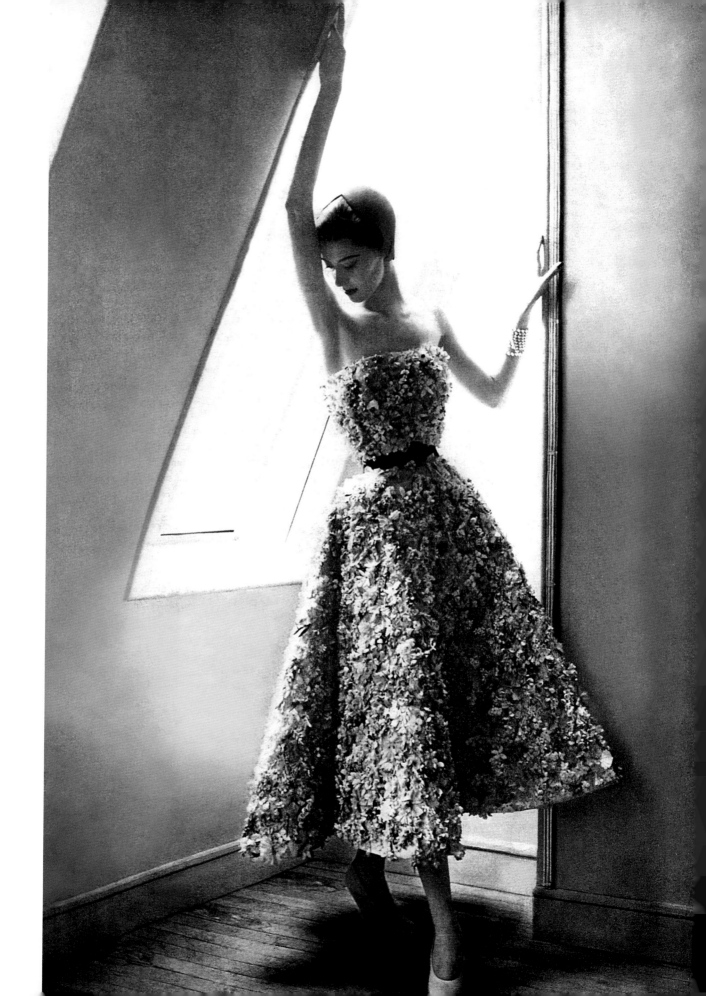

Daniel Jackson, 2013. Jennifer Lawrence wears the *Miss Dior 1949* dress, Autumn–Winter 2013 Prêt-à-Porter collection.

In tribute to the *Miss Dior* dress created in 1949, Raf Simons designed a contemporary version in black leather.

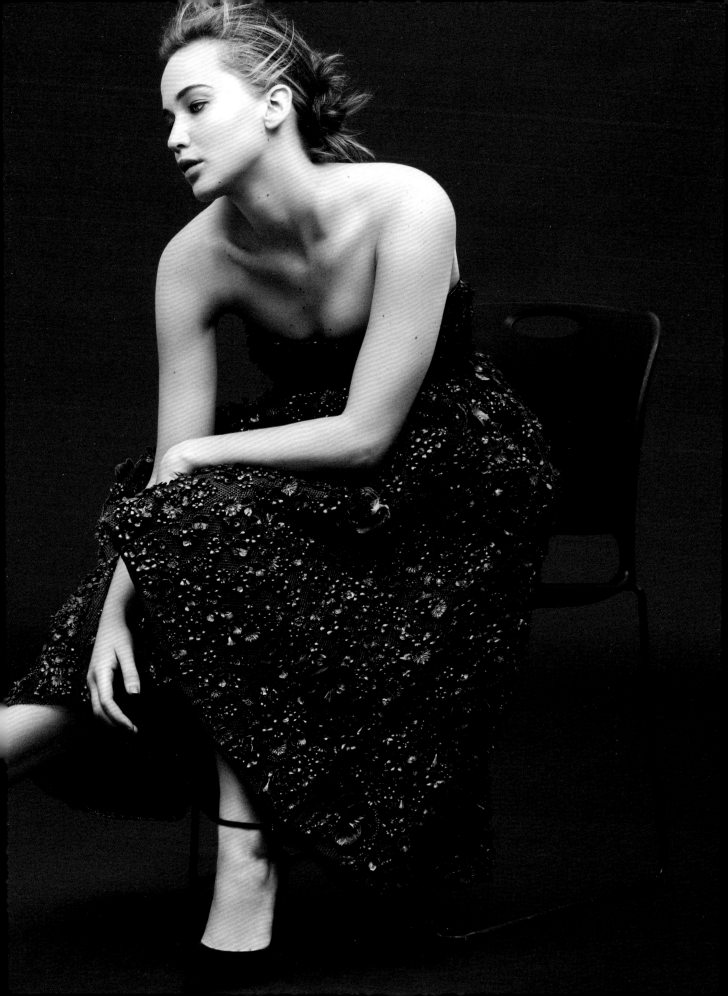

Four Visions of a Collection

Barbara Jeauffroy-Mairet

On July 1, 2013, the Dior couture show offered a singular experience, with images of fashion becoming the catwalk decor. Four of the greatest fashion photographers of this era had accepted Raf Simons's challenge to simultaneously shoot the models for the Haute Couture Autumn-Winter 2013 collection in four different photo studios set up backstage. Projected onto giant screens during the show, their portraits of models in front of a wall of flowers, posing solo or in groups, illustrated the collection devoted to travel on the four continents: Europe, with French photographer Patrick Demarchelier; Africa, with American photographer Terry Richardson; Asia, with Italian photographer Paolo Roversi; and the Americas, with Belgian photographer Willy Vanderperre.

Raf Simons, deeply familiar with and appreciative of their work, chose each photographer based on his particular aesthetic. Patrick Demarchelier knows the House of Dior intimately, as seen in his book *Dior Couture*, published in 2011, and his photographs of Charlize Theron in the Hall of Mirrors at Versailles; he brilliantly captures the Dior image of a Parisian woman. Terry Richardson offers a more outrageous take on Dior in shots brimming with freedom. Best known for his poetic, highly evocative work, Paolo Roversi strikes the perfect balance between the rigorous lines of suits and the dreaminess of evening gowns. Finally, Willy Vanderperre, who has shot the advertising campaigns since Raf Simons joined Dior, captures images of aloof beauties, poised yet assertive, framed like enigmatic family portraits.

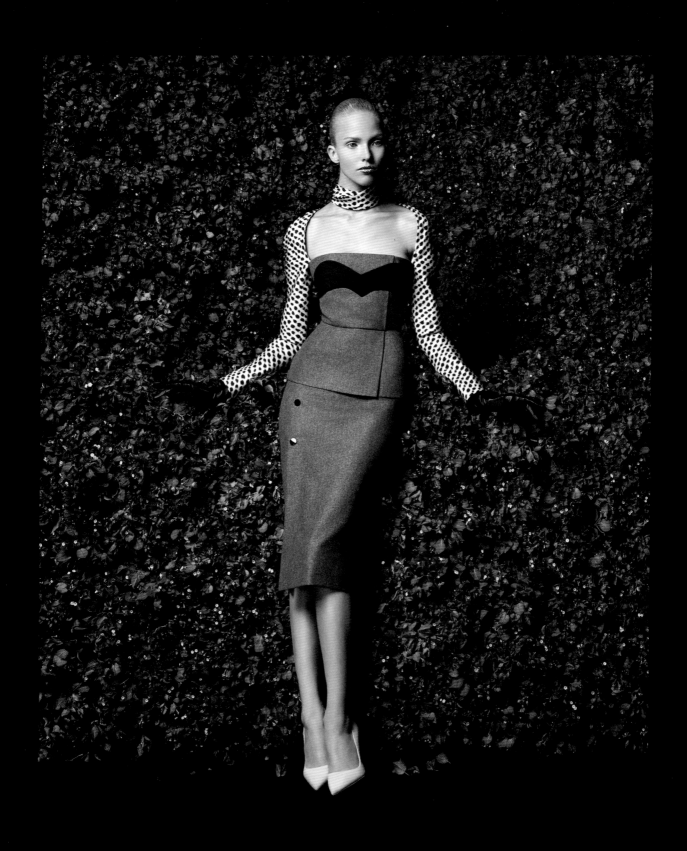

Patrick Demarchelier, 2013.
Ensemble from the Autumn–Winter
2013 Haute Couture collection.

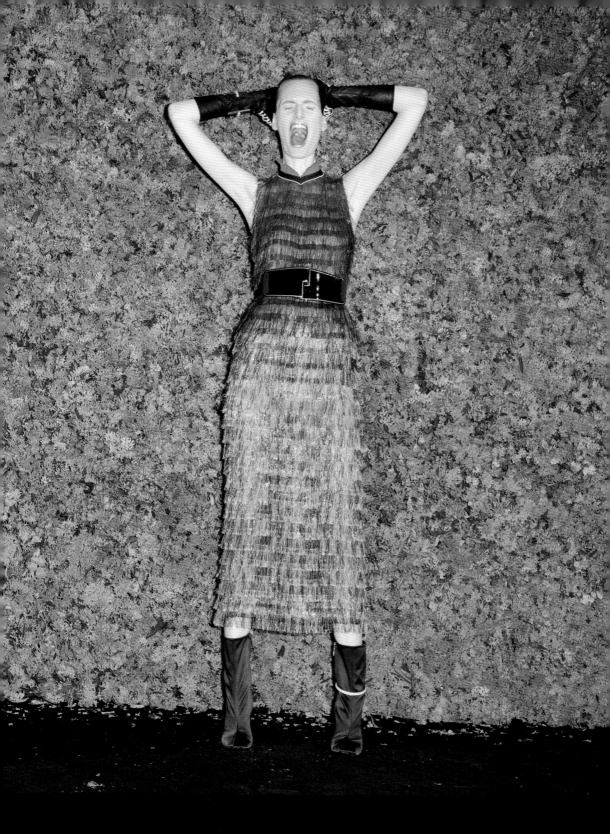

Terry Richardson, 2013.
Dress from the Autumn–Winter
2013 Haute Couture collection

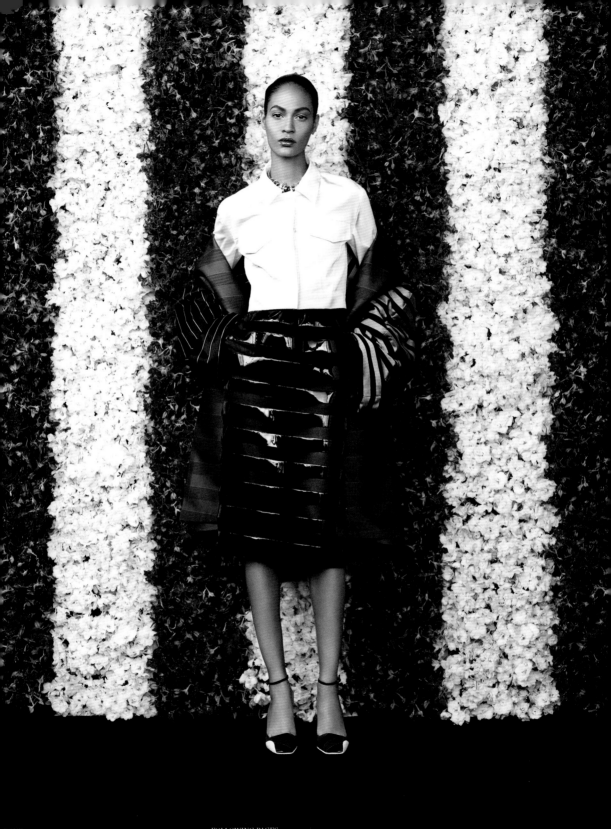

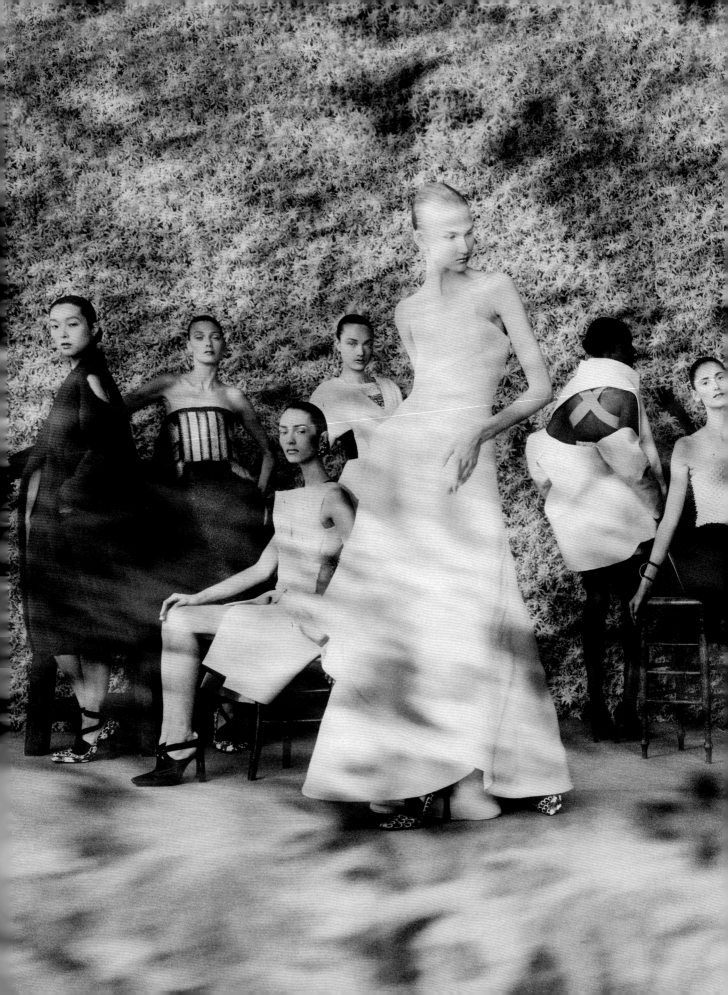

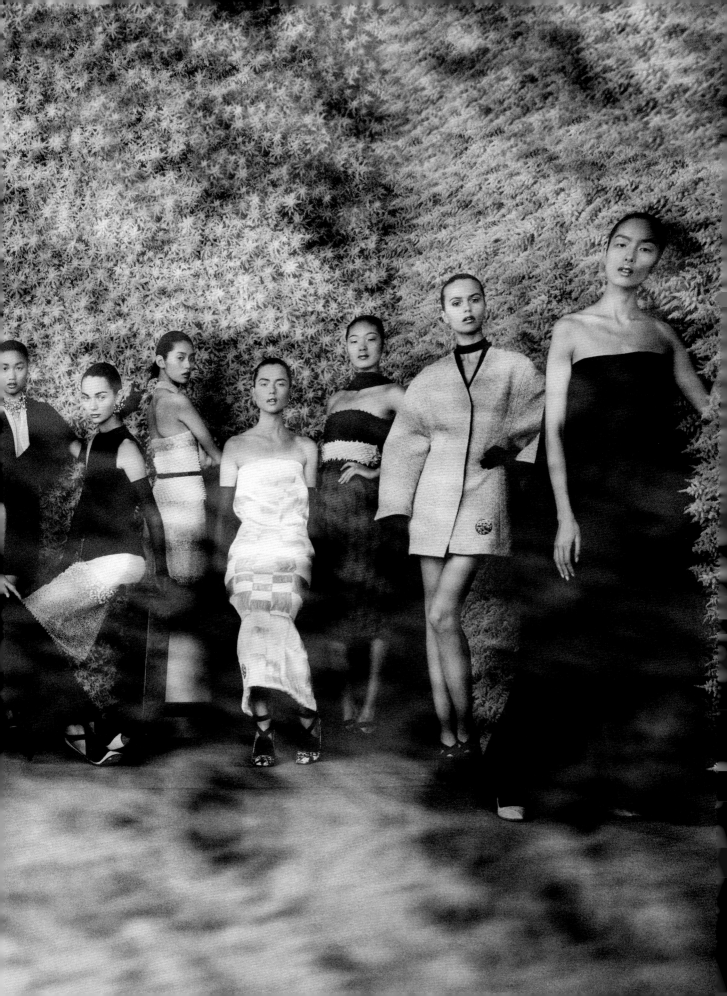

ACKNOWLEDGMENTS

This publication accompanies the exhibition *Dior, The Legendary Images,*
organized by the Présence de Christian Dior association at the Musée
Christian Dior in Granville from May 3 to September 21, 2014.

This project was made possible with the support of
Bernard Arnault, President of LVMH / Moët Hennessy • Louis Vuitton,
Sidney Toledano, President Chief Executive Officer Christian Dior Couture,
and Claude Martinez, President & CEO Christian Dior Parfums.

President of the Présence de Christian Dior Association
Jean-Paul Claverie

General Curator
Florence Müller

Scenography
Simon Jaffrot, assisted by Noémie Bourgeois,
Marie Docquiert and Benoît Police

Musée Christian Dior in Granville
Brigitte Richart, curator
Barbara Jeauffroy-Mairet, associate curator,
Marie-Pierre Osmont, Paule Gilles, and Ophélie Verstavel

Christian Dior Couture
Olivier Bialobos, Solène Auréal,
Séverine Breton, Cécile Chamouard-Aykanat, Gérald Chevalier,
Jérôme Gautier, Justine Lasgi, Philippe Le Moult,
Anne-Charlotte Mercier, Mathilde Meyer, Soizic Pfaff,
Hélène Poirier, and Perrine Scherrer

Parfums Christian Dior
Jérôme Pulis, Caroline Bernard,
Frédéric Bourdelier, Sandrine Boury-Heyler,
Lorraine Fagot, Vincent Leret, and Ludmilla Malinovsky

LVMH / Moët Hennessy • Louis Vuitton
Loïc Bégard

ACKNOWLEDGMENTS

The exhibition has been supported by:
The City of Granville, in particular the Mayor, Daniel Caruhel;
the Deputy Mayor and Cultural Officer, Patrick Bailbé;
Virginie Frouin, Director of the Tourist and Communication Office.
Ministère de la Culture, DRAC Basse-Normandie
Conseil général de la Manche
Conseil régional de Basse-Normandie
LVMH / Moët Hennessy • Louis Vuitton
Christian Dior Couture and Parfums Christian Dior

We would like to thank the institutions
who loaned their works for the exhibition:
Palais Galliera – City of Paris Museum of Fashion,
in particular Olivier Saillard, Sylvie Lécallier,
Véronique Belloir, Corinne Dom, and Alexandre Samson.
Musée des Arts décoratifs, in particular Olivier Gabet,
Pamela Golbin, Marie-Hélène Poix, Éric Pujalet-Plaà,
Joséphine Pellas, and Myriam Tessier.
Musée Nicéphore Niépce, in particular Audrey Hoareau.
Vogue Paris, in particular Amélie Airault De Andreis,
Caroline Berton, and Vanessa Bernard.
Fondation Pierre Bergé-Yves Saint Laurent, in particular
Pierre Bergé, Sandrine Tinturier, and Pauline Vidal.
The Museum at FIT – Fashion Institute of Technology,
in particular Valerie Steele and Melissa Marra.

Private Collections:
Archives Didier Ludot, in particular
Didier Ludot and François Hurteau-Flamand;
Dominique Issermann; Barbara Sieff.

Many thanks to Patrick Demarchelier, Arthur Elgort, Nan Goldin,
Jean-Paul Goude, Ruth Hogben, Dominique Issermann, Daniel Jackson,
Peter Knapp, Nick Knight, Annie Leibovitz, Peter Lindbergh, Serge Lutens,
Tiziano Magni, Jean-Baptiste Mondino, Terry Richardson, Paolo Roversi,
David Sims, Melvin Sokolsky, Mario Sorrenti, Tyen, Willy Vanderperre,
Inez van Lamsweerde and Vinoodh Matadin, and Bruce Weber.

ACKNOWLEDGMENTS

Association Willy Maywald (Jutta Niemann), Horst P. Horst Estate (Andrew Cowan), Münchner Stadtmuseum – Sammlungsleiter Fotomuseum (Ulrich Pohlmann, Margarete Gröner and Elisabeth Stürmer), Norman Parkinson Archive (Alex Anthony), The Center for Creative Photography (Tammy Carter), The Helmut Newton Estate (Maconochie Photography – Tiggy Maconochie and Robert Pritchard), The Irving Penn Foundation (Matthew Krejcarek), The Lillian Bassman Estate (Paul and Lillian Himmel), The Richard Avedon Foundation (Eugenia Bell).

Marion Cotillard, Victoire Doutreleau, Bettina Graziani, Milla Jovovich, Jennifer Lawrence, Robert Pattinson, Natalie Portman, Charlize Theron, and Natalia Vodianova.

The models Jemma Baines and Marta Dyks (Next Models); Isis Bataglia (Metropolitan); Naomi Campbell (Marilyn Agency); Kate Moss (Storm Models); Daiane Conterato, Marine Deleeuw, Sasha Luss (Elite Model Management); Kelly Moreira (Ford); Linda Evangelista, Meng Huang (DNA Models); Jerry Hall (Trump Model Management); Sun Hee, Jac Jakaciak, Kiara Kabukuru, Karlie Kloss, Yumi Lambert, Diana Moldovan, Amanda Murphy, Sasha Pivovarova, Joan Smalls, Antonia Vasylchenko, Daria Werbowy (IMG); Saskia de Brauw, Xiaomeng Huang (Viva); Chiharu Okunugi (Nathalie Models); Alexandra Martynova (City SF); Carolina Sjostrand (Wilhelmina Models); Fei Fei Sun, Iselin Steiro, Daria Strokous (Women Management); Ming Xi (NY Society); Caroline Trentini (Oui Management); Zazie Alliotte; Kristina Semenovskaia; Debra Shaw; Dorothea McGowan; Susan Moncur; Anne Rohart; Rita Scherrer; and Yvonne Sporre.

We also thank all those whose help has been so invaluable in preparing, creating and promoting the Dior, The Legendary Images *exhibition and catalogue:*
Arnaud Adida (A.galerie), Lucien Audibert, Djilali Boubekeur (Hachette Filipacchi Associés), Authentic Brands Group (Marilyn Monroe Estate), Émilien Bouglione, Émilien-Sampion Bouglione and Fabrice Bing (Le Cirque d'Hiver), Rachel Brishoual and Carol Chabert (Photothèque des musées des Arts décoratifs), Raphaëlle Cartier and Christophe Mauberret (RMN-Grand Palais), Farid Chenoune, Marion Colas (Adagp), Sarah Dawes (David Sims Studio), Dominique Deschavanne (Contact Press Images), Charlotte Evrad, Magali Galtier (Gamma Rapho), Andrea Gelardin and Charli Davis (Gelardin Management), Pascal Gillet, Cosima Glaister (The Condé Nast Publications Ltd), Kara Glynn, Alina Grosman and Gregory Spencer (Art Partner), Laziz Hamani and Antoine Lippens, Emma Hernandez (Dominique Issermann), Andy Howick (mptvimages), Gilles Hamel, François Hurteau-Flamand, Florent Kieffer, Nathaniel Kilcer (Little Bear Inc.), Nikandré Koukoulioti (Magnum Photos), Virginie Laguens and Claire Litolff (Jean-Paul Goude), Kimberly La Porte (Art+Commerce), Lisa Lavender (Bert Stern Productions), Joël Leloutre, Joanna Ling and Katherine Marshall (Sotheby's), Édith Mandron (*Elle*), Barbara Mazza (Roger-Viollet), Mia Meliava (Iconoclast Image), Leigh Montville (Condé Nast Licensing), Margaux Nelkin (Art+Commerce), Julien de Passorio Peyssard (Getty Images), Alexandre Percy (acte2galerie), Lauren Pistoia (The Collective Shift), Dr. Roth & Kollegen (Marlene Deitrich Collection), Stewart Searle (M.A.P.), Aline Souliers, Hervé Szerman (PhotoSenso – Trunk Archive), and Michèle Zaquin.

Outfits designed by Christian Dior (1947–1957):
pages 6, 10–35, 43, 45, 47, 49, 55, 56, 64–65, 74, 75, 86, 93, 118–119, 122–123, 139.
Christian Dior outfits designed by Marc Bohan (1961–1989):
pages 9, 66–71, 80–81.
Christian Dior outfits designed by John Galliano (1997–2011):
pages 53, 62–63, 72–73, 78–79, 85, 87–91, 107, 124–125, 128–129, 142–143.
Christian Dior outfits designed by Raf Simons (since 2012):
pages 61, 76–77, 113–116, 121, 127, 131–137, 140–147.